NIGHT THOUGHTS

OR

THE COMPLAINT

AND

THE CONSOLATION

Illustrated by William Blake

Text by Edward Young

Edited, with an Introduction and Commentary, by

Robert Essick
California State University, Northridge

Jenijoy La Belle
California Institute of Technology

Dover Publications, Inc.
Mineola, New York

Bibliographical Note

This Dover edition, first published in 1975 and reissued in 1996, is an unabridged republication of the work first published in London by Richard Edwards in 1797, under the title *The Complaint, and The Consolation; or, Night Thoughts*. Robert Essick and Jenijoy La Belle have prepared a new Introduction, Commentary on Blake's Illustrations, and Bibliography especially for this Dover edition. The 1797 edition is reproduced at 65% of original size.

Library of Congress Cataloging-in-Publication Data

Young, Edward, 1683–1765.
 Night thoughts, or, The complaint and the consolation / illustrated by William Blake ; text by Edward Young ; edited, with an introduction and commentary, by Robert Essick, Jenijoy La Belle.
 p. cm.
 Includes bibliographical references (p.).
 ISBN 0-486-29214-2 (pbk.)
 1. Didactic poetry, English. 2. Didactic poetry, English—Illustrations. I. Blake, William, 1757–1827. II. Essick, Robert N. III. La Belle, Jenijoy, 1943– .
IV. Title.
PR3782.N5 1996
821'.5—dc20
 96–12356
 CIP

Manufactured in the United States of America
Dover Publications, Inc., 31 East 2nd Street, Mineola, N.Y. 11501

INTRODUCTION
TO THE
DOVER EDITION

Strange as it may seem to us, there was a time when the name of Blake was known to only a few and Young's name was virtually a household word, as familiar as "Shakespeare" or "Milton" and often indeed uttered in the same breath with those still and always imposing names. Today it is Blake's illustrations which alone protect Young's poetry against the tooth of time and razure of oblivion.

Edward Young (1685–1765) was enormously popular for over a hundred years. His finest achievement, *The Complaint, and The Consolation; or, Night Thoughts*, written in the 1740's when he was in his early sixties, was widely read and revered. It was reprinted more often than almost any other book of the eighteenth century. The poem was praised by Boswell, memorized by Burke, and imitated by Hervey. Before 1844 it had been translated into twelve languages, including Spanish, Swedish, Portuguese, and Magyar, and was especially admired in Germany and in France (Robespierre kept it under his pillow throughout the Revolution).

But how changed today! In 1857 George Eliot scathingly attacked Young and his poetry. The person who to Dr. Johnson had been "a man of genius and a poet" was to her "a cross between a sycophant and a psalmist." The nineteenth century found false that religious and moral spirit which had so exalted the eighteenth. And most modern readers continue to object to Young's sometimes lugubrious and always egocentric versified moral lectures. *Night Thoughts* rambles on in blank verse for over 10,000 lines, many of them redundant. There are fine individual passages that can attract the modern reader, but most of us today come to Young circuitously, through William Blake's overpowering illustrations.

In 1795 Richard Edwards, a bookseller and publisher, contracted William Blake to do a series of designs for *Night Thoughts*. Thus this commission came when Blake was 38 years old and towards the end of one of his most productive periods, when he was publishing through his own unique method of relief-etching a number of his greatest poems, including the *Book of Urizen, America, Europe,* and *The Song of Los.* Blake set out to illustrate all nine of the Nights (Young's name for the major sections of his poem), and, with what must have been inexhaustible energy, completed in less than two years 537 watercolor designs, done on large folio sheets with the text of the *Night Thoughts* set into the center of the pages. From these watercolors, forty-three were selected from the first four Nights, and these were engraved by Blake and published in 1797. The project apparently proved to be financially unsuccessful, for after this first volume, no further volumes were issued. It is this Edwards edition of the first four Nights that is here reproduced for the first time in its entirety, reduced about 35% from its original dimensions.

Blake is a very careful illustrator of Young's text, but at the same time, through the use of motifs that appear in his other designs and in his own poetry, Blake is continually referring us to his own ideas and reactions to what Young is writing, so that the illustrations are not simply decorative but form a running commentary on Young's poem. Thus these illustrations are important for several reasons. Not only are they the longest series of designs by the most imaginative and dynamic illustrator England has ever produced, but also they are important documents in the history of criticism and taste since they record visually the response by a great but then largely unknown poet to one of the most popular writers of his own era. By giving concrete form to Young's images, Blake is literally faithful to the text while escaping the abstractions and self-centeredness of Young. Like Shakespeare's poet in *A Midsummer*

Night's Dream, Blake "bodies forth the forms of things unknown" and "turns them to shapes, and gives to airy nothing a local habitation and a name." Blake gives energetic form to Young's sometimes stale personifications. As J. Comyns Carr wrote in 1875, "Blake both obeys the text and rises above it . . . at other times he escapes altogether through the loophole of a stray simile" (see item 3 in the Bibliography).

The way in which Blake arranges his illustrations around the central text panel contributes to their meaning. Blake wrote in *Jerusalem*, "What is Above is Within," and the upper portions of the *Night Thoughts* designs are frequently devoted to emblems or spiritual presences who comment upon the powers or limitations of those below. Upward thrusting movements show attempts to transcend natural barriers; downward thrusts show the influence of the supernatural on mortals. Circular designs embody the cycles of life: generation and decay, night and day, time and eternity. Young's lines are the literary hubs about which Blake's images whirl, expanding both spatially and iconographically.

Although in some designs Blake implicitly criticizes Young, it would be wrong to over-emphasize the opposition between poet and illustrator. Blake's own sensibilities have more in common with the Graveyard School of eighteenth-century poetry (of which the *Night Thoughts* is a leading example) than some of Blake's admirers are pleased to admit. Young had an important effect on Blake's development as a poet. As early as 1784 Blake referred to the *Night Thoughts* in his prose satire, *An Island in the Moon*, and the fact that Blake divided his own epic, *Vala, or The Four Zoas*, into nine Nights is sufficient evidence of this influence. And perhaps it was a sense of symbolic continuity, rather than simply a paper shortage, motivating Blake when he wrote parts of *Vala* on proof sheets of his *Night Thoughts* engravings.

Although conventionally described by the generic term "engravings," the *Night Thoughts* illustrations reproduced here are in part etchings. Blake covered his copperplates with an acid-resistant varnish in which he could draw his designs with an etching needle to expose the metal wherever he intended an etched line to appear. The plate was then placed in an acid bath to eat away channels in the copper to hold the ink. After the varnish was removed from the plate, Blake could then work on the copper with an engraving tool, improving the etched lines and adding many new ones. From the print connoisseur's point of view, these plates are not altogether successful, showing a tendency towards extravagance and a lack of technical control of the medium. But in spite of these deficiencies they have a vitality and spontaneity which set them off from all other late eighteenth-century book illustrations characterized by their high finish and boring conventionality. It is also possible that Blake purposely left out details to allow for subsequent coloring. Indeed, there are about twenty known colored copies of the book, some probably done by Blake himself and others after his models.

Edwards or his printers obviously had trouble with the physical coordination of text and design since they had to be printed in two separate operations. On some pages the text and text panel are not properly aligned. In the copy reproduced here, now in the collection of Robert Essick, the page number extends above the panel on pages 80, 86, and 90, while on page 55 the last line of text drops beneath the panel. Furthermore, the copperplates were not in every case correctly positioned on the folio sheets. Since the plates are only slightly smaller than the pages, some designs are trimmed on one or two margins—even in uncut copies. Where the plate was placed too low on the page, the illustration has lost its imprint giving the publisher's name, place of business, and date. In some cases the printer has cut off part of Blake's monogram signature engraved on most of the plates—"WB," with "inv." ("invenit," meaning Blake designed the picture) and "sc." ("sculpsit," meaning he also engraved the plate) in a semicircle above the initials. Within the first few pages, for example, both imprint and monogram can be seen clearly on pages 7, 15, and 16 of the copy reproduced here; but the imprint is cut off on pages 10 and 12. In this copy only page 87 has the monogram cropped.

For their kind assistance in preparing this edition we wish to thank Jenny Wren Weeks and Professors Morton D. Paley, John E. Grant, and Edward J. Rose.

ROBERT ESSICK
JENIJOY LA BELLE

December 1974

COMMENTARY ON BLAKE'S ILLUSTRATIONS

The following plate-by-plate notes are intended as a general guide to Blake's iconography in the *Night Thoughts* engravings and as a stimulus to more thorough studies. The emphasis is on description and suggestive reference—to Blake's own poems and pictures as well as to Young's text. A full consideration of the multiple correspondences between designs and the importance of their sequential relationship would have to focus on the complete series of 537 watercolor designs rather than the 43 engraved illustrations reproduced here.

Quoted at the beginning of the commentary for each plate is the appropriate entry from the "Explanation of the Engravings," which was printed on a single sheet and bound into some copies of the Edwards edition. These explanations are, with a few notable exceptions, sensible in relating the engravings to Young's text, but they are rather obvious and do not explain the particular Blakean meanings latent in the designs. Their authorship has never been conclusively determined, but they certainly are not by Blake himself. The explanations were tentatively attributed to Blake's friend and fellow artist Henry Fuseli in Alexander Gilchrist's *Life of Blake*, 1863, though there is no reason to think that this conjecture has any authority. Most of the pages with designs also have one line of the poem marked with an asterisk to indicate the specific passage illustrated. But these are not always accurate, for Blake often embodies in his designs major themes or image patterns only partly developed in any single passage. In the watercolors, the lines marked for illustration sometimes differ from those indicated in the engravings.

Title-Page to Night the First
(On Life, Death and Immortality)

Death, in the character of an old man, having swept away with one hand part of the family seen in this print, is presenting with the other their spirits to immortality.

The giant figure of Death appears here in one of his more benign aspects. As in Young's title to this Night, he is the central term which links together earthly Life and Immortality. His closed (or downcast) eyes suggest both blind fate and blind justice—all creatures are inevitably caught by his hand. Further, the workings of mortality are invisible, and thus Blake makes Death sightless through a pictorial equivalent to the grammatical reversal of subject and object—as he did in 1795 with Shakespeare's "sightless couriers of the air" in the color print "Pity." Young later calls death an "insatiate archer" (p. 8), and Blake duly gives his ancient man an arrow and bow, half-hidden in the folds of his gown on the left. A family group, presumably a mother and her five children, seem unaware of Death's approach. Two children play with a lyre, a symbol for poetry in subsequent designs; a curly-haired boy presents a scroll to his mother; and a fourth, only partly visible, appears to be reading a book balancing above the woman's right knee. In the foreground a young boy writes on a tablet, his closed and bent posture suggesting that assumed by the limited and limiting figure of Urizen in Blake's Illuminated Books and the restricted poet on the blank verso of the Preface in the watercolor series. The woman, adorned with a fashionable eighteenth-century coiffure, pulls a thread from a distaff, an important image in Blake's poetry and paintings for "generation" or biological existence. She is the "Mother of my Mortal part" (Blake, "To Tirzah"), while Death works here as the father of immortality. A lovely female nude reaches

above to be "deliver'd from the Body on the left hand" (Blake's *Milton*, Pl. 26). Using progressive representation, Blake pictures at once both the physical form and the airy spirit to which it will be translated. To stress the immaterial nature of the soul, Blake runs his parallel lines of shading in the sky right through the energetic figure being welcomed by angels who are just as substantial, just as "real," as the humans below.

Page 1
Sleep forsaking the couch of care, sheds his influence, by the touch of his magic wand, on the shepherd's flock.

The youthful pastoral poet remains awake, his face drawn by thoughts of "fancied misery" and his head propped on his arm in the traditional posture of the melancholic, while the flock and sheeplike dog (more obviously canine in the watercolor) rest under the beneficent magic of winged Sleep. The poet's cloak is wound about his body as if it were a shroud or "a worm . . . wrapt round and round" (p. 6). Like the worms in many of Blake's paintings or the cocoon-child on the frontispiece to Blake's *The Gates of Paradise*, this poet is bound to the mortality of earthly creatures, a companion to the vine rising weakly up the left margin. The clouds form a tentlike enclosure, particularly for the recumbent figure above the text panel who suggests at once both peaceful repose and the final rest of death.

Page 4
*The imagery of dreaming variously delineated according to the poet's description in the passage referred to by the *.*

The poet is now asleep over his open book, but, above, Blake portrays the dream wherein the poet sees himself cautiously exploring the "pathless woods," rising on "hollow winds" to dance with one of the "antick shapes wild natives of the brain," dangling over the "craggy steep" of the text panel, and hurling "headlong" down the right margin. Finally, with the

graceful arm and head position of the figure in flames on Plate 3 of Blake's *Book of Urizen*, he swims in a "mantled pool." Blake closely illustrates the text, but he has rearranged Young's sequence of images to create a rising and falling action revolving about the text. The cycle also embodies an emotional sequence—curiosity, rising expectancy, joyful meeting with the female figure, fear, horror, and finally immersion.

Page 7
Death, tolling a bell, summonses a person from sleep to his kingdom the grave.

The open book and quill identify the startled figure as the poet, while the "streaming sands of life" (p. 13) all in the lower bell of the hourglass warn of Death's approach. Three of these objects behind the poet—hourglass, lamp or candle, and open book—are, when grouped together, a traditional emblem for making proper use of time. In Geoffrey Whitney's *A Choice of Emblemes*, 1636, they are arranged on a table in the same order presented in this *Night Thoughts* design to illustrate the following moral: "Wherefore beholde this candle, booke, and glass: / To use your time, and knowe how time dothe pass."

Death's visage is far more frightening than on the title-page, but here too his bow and arrow are not seen by his victim. The similarities between Death with his long white beard, knitted brow, and massive left knee and Urizen throughout Blake's Illuminated Books are particularly striking in this design. The sense of oppression is further emphasized by rectilinear forms—the triangles of the hourglass and oversize bell, the table and cube beneath the lamp, and the harsh diagonal extending from the text panel to the right margin just above Death's head. Another bellman of death is portrayed on Plate 7 of Blake's *Europe*, but his stance and general appearance are not the same as they are here.

Page 8
The universal empire of Death characterized by his plucking the sun from his sphere.

Death launches his dart even at the sun, already in his grasp. His feet tread on youthful crowned monarchs stacked like so much cordwood. A similar arrangement of corpses appears on the title-page to Blake's *America*. Although the hubris portrayed here is not part of Los's character, this *Night Thoughts* design foreshadows the apocalyptic destruction of the material sun and earthly kingdoms in Blake's *Vala*:

> Los his vegetable hands
> Outstretch'd; his right hand, branching out in
> fibrous strength,
> Siez'd the Sun; . . .
> The thrones of Kings are shaken, they have
> lost their robes & crowns, . . .
> (Night the Ninth, lines 6–8, 18)

Page 10

An evil genius holding two phials, from one pours disease into the ear of a shepherd, and from the other scatters a blight among his flock; intimating that no condition is exempt from affliction.

The "Explanation" sufficiently explains the relation of design to text. Although young and seemingly feminine, the descending personification of disease—or the sins that cause disease—has a snaky trail of clothing similar to Urizen's on Plate 4 of *Europe*. The shepherd and now short-haired dog, supposedly protectors of the flock, sleep on. Disease or pestilence poured from vials was a stock eighteenth-century motif, and appears again on Plates 5 and 6 of Blake's *Job* designs and in "The Evil Race," one of Flaxman's illustrations to Hesiod.

Page 12

The frailty of the blessings of this life demonstrated, by a representation in which the happiness of a little family is suddenly destroyed by the accident of the husband's death from the bite of a serpent.

In this design Blake extends his symbolism far beyond the realm of mere illustration, i.e., the literal translation of the text into equivalent visual images. In about 1788 Blake had used the mother, child, and bird group on Plate 5 of *There Is No Natural Religion*, First Series, in conjunction with the statement that "Man by his reasoning power can only compare & judge of what he has already perciev'd." The relationship between this motto and the passage from the *Night Thoughts* illustrated here is not altogether clear, but it is likely that the motif retains its suggestions of bondage to the world of reason and natural perceptions. The child, struggling against adult restraint, attempts in turn to restrain the free-flying bird, thus preventing it from either singing or soaring like those above and to the left of the text panel. As Young states it, ". . . while we clasp [joys], we kill them"; or in the words of Blake, "He who binds to himself a joy / Doth the winged life destroy" (from the *Notebook*). The child's fate is imaged by the man, perhaps his father, crucified on the "rock of adamant" of the material world and constricted by the "envenom'd" serpent of nature. In an ironic turnabout, the would-be captor will become a captive; the pursuit of "favours" will end in "trials." Young emphasizes the moral lessons of experience: ". . . beware / All joys" of this world. Blake uses this as a starting point to show the restrictive and deadly cycle of natural existence, just as he does in some of his *Songs of Experience*. Unlike the bird whose song rises above ivy tendrils (a Blakean symbol for nature's cruelties), father, mother, and child are trapped by "cause and consequence."

An alternative approach juxtaposes adults and child and takes the bird for a traditional emblem of poetry and imagination—a "joy that never can expire." Thus the mother, like the serpent, crushes all attempts to rise above nature to a higher level of perception. This interpretation, however, carries the design even further from Young's poem and implies an opposition between text and design in *There Is No Natural Religion*.

Page 13

The insecurity of life exemplified by the figure of Death menacing with his dart, and doubtful which he shall strike; the mother, or the infant at her breast.

A blind Death swoops down on a mother and child who in their own way are blind to death as they look lovingly, almost hypnotically, into each other's eyes. Blake used this odd face-to-face positioning for two adults in the second design to his poem *Tiriel*. There it represents the limited, self-involved vision of decadent pastoralism, but since it is a mother and child, the motif in *Night Thoughts* may not have the same meaning.

Page 15

The author encircled by thorns, emblematical of grief, lamenting the loss of his friend to the midnight hours.

Page 16

The struggling of the soul for immortality, represented by a figure holding a lyre and springing into the air, but confined by a chain to the earth.

On pages 15 and 16 of the text Young complains about his own failures as a poet, unable to fully embody his emotions in verse. Through the imagery of his designs, Blake suggests some reasons for Young's limitations. "Grief's sharpest thorn" (p. 16) grows in the engraving on page 15 into intertwined vines binding the poet to earth. On page 55 in the *Night Thoughts* engravings and elsewhere throughout Blake's work these thorny tendrils crisscross graves, for this poet is also buried in the "grave" of the material world "binding with briars my joys & desires" (Blake's "The Garden of Love"). Further restraint is presented by the chain about the poet's ankle, the "mind-forg'd manacles" (Blake's "London") of the poet who gazes downward at his book, entertaining only night thoughts, and unable to soar like the bird above the text panel into realms of spiritual illumination. For Blake the natural world is not in itself evil; it is the mind of the poet represented here that turns it into briars and chains.

On the lower left of page 15 is a tiny bird, perhaps the nightingale, the "sweet philomel" who calls "the stars to listen" (p. 16). But more likely it is the lark, the bird of inspiration in Blake's *Milton*, who sings its "shrill matin"

(p. 16) to call down a light-clad representative of morn. In contrast, the poet's companion is the dark-gowned melancholic seated on his thigh. Other personifications of the "silent hours" (p. 16) freely ascend on the right. The upper figure, strangely cut off just above the waist, suggests ascent even beyond the pictorial space of the engraving, and may also be Blake's literalization of Young's metaphor for man's forgetfulness of mortality: "... their hearts wounded, like the wounded air, / Soon close; where pass'd the shaft no trace is found. / As from the wing no scar the sky retains" (p. 15).

The design on page 16 contradicts the line marked by the asterisk. In spite of the poet's attempts to fly "beyond the bounds of Life," the heavy chain, now rooted in the earth with the briars, retards his flight. The poet holds a lyre, emblem of lyric poetry, rather than the bardic harp often used by Blake as the symbol for the nobler genre of epic (see "The Voice of the Ancient Bard" in *Songs of Innocence*). Rather than the line indicated, Blake continues to portray Young's confessed inability to reach the high strain of Milton's epic voice in a way that suggests the imagery of a passage in Night the Second: "Our freedom chain'd; quite wingless our desire; / In sense dark-prison'd all that ought to soar" (p. 30). Young was too limited in his inspiration and poetics to handle the grand themes of life, death, and immortality. At about the same time he was illustrating *Night Thoughts*, Blake himself began to write a visionary epic, *Vala*, to succeed where he believed Young had failed.

Title-Page to Night the Second
(On Time, Death and Friendship)
Time endeavouring to avert the arrow of Death from two friends.

A not-so-grim reaper protects from ancient Mortality two friends, one the poet with his lyre. His giant wings temporarily at rest, Time has ceased his usual flight and reveals himself to be, at least for the moment, a beneficent power. The scythe cuts down, but it is at the same time an instrument of life-giving harvest. The wreath of flowers intertwined about Time's head suggests mutability, but also his victory

over Death and the gentle union of the young men holding hands. Blake has borrowed the forelock of "Occasion" as represented in many emblem books to create Time's coiffure. The significance of this hairstyle is explained in Whitney's *Choice of Emblemes*:

> What meanes longe lockes before?
> *that such as meete,*
> *May houlde at first, when they occasion finde.*
> Thy head behinde all balde, what telles it more?
> *That none shoulde houlde, that let me slippe before.*

In this *Night Thoughts* illustration, unlike the title-page to Night the First, the occasion for Death has not yet arrived. He has yet to grasp the forelock of Time. Throughout his designs for Night the Second, Blake combines traditional images of time and occasion to model a figure at once both destructive and conservative—similar in this respect to Los, the hero of creative time in Blake's Prophetic Books.

Page 19

A skeleton discovering the first symptoms of re-animation on the sounding of the archangel's trump.

On this page of the poem Young writes of the crowing cock; in the design Blake directly visualizes that for which the cock is only an "emblem"—the trumpet blast which "shall awake the dead." Blake later used much the same design for the title-page to his illustrated edition of Blair's *The Grave*, and also described the same apocalyptic moment in *A Vision of the Last Judgment*: "The Graves beneath are open'd, & the dead awake & obey the call of the Trumpet; . . . a Skeleton begins to Animate, starting into life at the Trumpet's sound." The descending trumpeter awakening the dead also occurs on the title-page for Blake's *Vala*.

Page 20

Although unillustrated, this page contains a line preceded by an asterisk. It is likely that the design on page 6 of the watercolors (*Night Thoughts 39*), where this same line is marked for

illustration, was originally intended to be included among the engraved designs and, when excluded, the asterisk was overlooked and not removed. The watercolor depicts an encounter between two men beneath a tree and in front of a flock of sheep.

Page 23

A man measuring an infant with his span, in allusion to the shortness of life.

Blake presents a visual equivalent to Young's temporal concept of "a span too short" by portraying a father measuring with his hand an "Infant a span long" (Blake's *Vala*). Several motifs suggest that this procedure is more sinister than it might at first seem. The man's hand forms a triangle like that created by the compasses of the "Ancient of Days" who delimits the material world on the frontispiece to Blake's *Europe*. In the color print of "Newton," Blake shows the scientist also leaning over with a mantle cascading from his shoulder to measure out and quantify existence with triangular compasses. The *Night Thoughts* design similarly suggests the burdening of youthful energies by adult reason. As Blake writes in *Tiriel*, "The child springs from the womb; the father ready stands to form / The infant head." In the background stands a rectilinear, tomblike structure, adorned with two angels bent over in sorrow. Is the father measuring his babe for a cradle, or a coffin? In the watercolor, *Night Thoughts* 44, the babe has his back turned to the viewer.

Page 24

Our inattention to the progress of Time illustrated by a figure of that god, (as he is called by the poet) creeping towards us with stealthy pace, and carefully concealing his wings from our view.

Page 25

Time having passed us, is seen displaying his "broad pinions," and treading nearly on the summit of the globe, eager "to join anew Eternity his sire."

These two designs illustrate the same passage on page 24, and thus there is no line marked with an asterisk on page 25. In the first scene Time advances slowly, his scythe in one hand and the other spread out in a way similar to the father's measuring span in the previous illustration. Here Time clearly presents his forelock, while on page 25 only his bald head is seen as he flies off. The emblematic significance of this change is adequately described by Whitney in the passage quoted in the commentary to the title-page of Night the Second.

On the bottom of page 23 Young writes that the "telescope is turn'd" to signify that instant when the slow approach of Time changes to rapid flight. Blake's hourglass at the top of page 24 records the same event; it too has just been "turn'd" and all its sands rest temporarily in the upper vessel. Over the glass slumps a youth, "weary of time" like Blake's "Sun-Flower" in *Songs of Experience*. Young's brief excursion into the psychology of time must have appealed to Blake, himself an explorer into apocalyptic moments of temporal reverse. In *A Vision of the Last Judgment* Blake wrote of his own difficulties as an artist in representing Time: "The Greeks represent Chronos or Time as a very Aged Man; this is Fable, but the Real Vision of Time is in Eternal Youth. I have, however, somewhat accomodated my Figure of Time to the common opinion, as I myself am also infected with it & my Visions also infected, & I see Time Aged, alas, too much so." In the engraving Blake added to Time's arms and legs the prominent veins not visible in the water-color (*Night Thoughts* 45).

Page 26
The same power [time] in his character of destroyer, mowing down indiscriminately the frail inhabitants of this world.

Time's destructive power has been latent in his presentation in previous designs, but now his "enormous scythe, whose ample sweep / Strikes empires from the root" (p. 7) comes into play. His face and forelock turned from us, he cuts down all—"Fathers & friends, Mothers & Infants, Kings & Warriors" (*Vala*, Night the Ninth, line 243). The crowned and helmeted

corpses beneath Time's left knee are as rigid as the sepulchral monuments which Blake drew while an apprentice engraver. As an illustration to Young's text on this page, Time's victims are "Hours, days, and months, and years"—his children whom he, Cronos-like, destroys.

Page 27
Conscience represented as a recording angel; who is veiled, and in the act of noting down the sin of intemperance in a bacchanalian.

Conscience stands on the right "behind her secret stand" (p. 28) extending below the text panel, noting the excesses of a drinker whose cup bears a prophetic resemblance to Death's bell on page 7. Conscience's veil, cloak, dark dress, and tightly coiled hair all bespeak restraint. The veil in particular connects Conscience with Vala, Blake's nature goddess in his Prophetic Books, whose own veil represents repressive moral law (see particularly *Jerusalem*, Pl. 23). Blake gives to his personification of Conscience sinister qualities not part of Young's poem.

Page 31
A good man conversing with his past hours, and examining their report. The hours are drawn as aërial and shadowy beings, some of whom are bringing their scrolls to the inquirer, while others are carrying their record to heaven.

In another example of progressive representation, the poet consults the past. The "hour" at top left wears a bonnet, the next has her hair bound up, the three with scrolls have loosened hair, and the last has her hair bound once again. The return to Young's "heaven" seems to be for Blake a return to restriction, while the hour standing at the poet's knee holds her hand out in a gesture of admonition or denial. The hour above the poet's head takes further (derogatory?) notes on his behavior. The poet's chair grows into a tendril at the far right to associate him with the natural, rather than the spiritual, world, and suggests that he is something less than the "good man" of the "Explanation."

Page 33
Belshazzar terrified in the midst of his impious debauch by the hand-writing on the wall. The passage marked out by the asterisk, sufficiently explains the propriety with which the story is alluded to by the poet, and delineated by the artist.

Blake illustrates Young's allusion to the Biblical story of Belshazzar (Daniel, Chap. 5). The prophet bursting from clouds, his face marked with a terror almost equal to Belshazzar's, points to the message of mortality with a gesture very like John the Baptist's on the frontispiece to Blake's *All Religions Are One*. The writing on the wall is explained by Daniel 5:26–27: "MENE; God hath numbered thy kingdom, and finished it. TEKEL; Thou art weighed in the balances, and art found wanting." The cup of pleasure, already introduced on page 27, is now overthrown, as it is in "Death of the Strong Wicked Man," one of Blake's designs to Blair's *Grave*. Belshazzar's hair stands literally on end as he attempts to fend off the vision with his hand, palm outward. Both motifs were used again by Blake to portray Eliphaz when he sees his God on Plate 9 of the *Job* designs. Above the text panel rests an emblem of Belshazzar's future—a shrouded corpse, brother to the figure at the top of page 1, encircled by the worm of mortality. A similar motif appears at the bottom of Blake's fourteenth *Job* engraving.

Page 35
A parent communicating instruction to his family.

On the title-page to *Songs of Innocence* and in the design to "The School Boy" Blake presented scenes of imaginative education—a woman showing a book to children; a boy reading a book in the top of a lovely vine. In this *Night Thoughts* design Blake creates a scene of miseducation suggested neither by Young's poem nor by the brief "Explanation" quoted above. On the right sits a woman, her face lined with age, holding a child at her knee. In these respects she resembles Tirzah, "Thou Mother of my Mortal part" in *Songs of Experience*, and Enitharmon, the "aged Mother" in the *Song of Los* and elsewhere in Blake's poetry.

But the vegetative chair and the cloak draped over the old woman's head mark her, like Conscience on page 27, as also a prototype for Blake's nature goddess, Vala. The old man on the left bends over from his sinister, bat-winged chair and counts on his fingers. Like Urizen in Blake's Illuminated Books, and "Aged Ignorance" on Plate 11 of *The Gates of Paradise*, he teaches quantitative knowledge as restrictive as his own and his students' postures. We see here the next stage in a child's life after his initial encounter with measurement and numbers pictured on page 23. One youth has a single finger raised to follow the instructor's lesson, yet it also serves as a directive to the old man to look above. There he would find a representative of the music and poetry excluded from his world of numbers. The figure on a cloud to the right of the text panel seems both to listen with pleasure to the lyricist and to look with disdain on the earth-bound group caught between restrictive Nature and abstract Reason.

Page 37
The story of the good Samaritan, introduced by the artist as an illustration of the poet's sentiment, that love alone and kind offices can purchase love.

This design presents peculiar problems for its interpreter. If one follows the "Explanation" and traditional associations with the story of the good Samaritan (Luke 10:30–37), then the illustration represents an act of true giving and love. The Samaritan bends down to aid the suffering wayfarer while the priest and Levite named in the Bible travel on in the distance. These two are as incapable of humane acts as the horse munching grass behind the Samaritan. But one small feature, the cup with a serpent motif about its side, does not fit this straightforward interpretation. Not only does the serpent represent mortality throughout Blake's *Night Thoughts* designs, but the cup and serpent motif is also a traditional emblem for St. John the Evangelist. The Emperor Domitian once tried to kill St. John with a cup of poisoned wine, but a serpent sprang from the cup as a miraculous warning to the intended victim. Thus the prone figure in this illustration would

be quite justified in shunning, as he seems to do with his hand gesture, the offer of an ostensibly poisonous gift. The difficulties in reconciling the disparate allusions in the design are almost as great as recognizing true friendship.

Page 40
Angels attending the death-bed of the righteous, and administering consolation to his last moments.

Page 41
Angels conveying the spirit of the good man to heaven.

The two designs on pages 40 and 41 flow together naturally to create a single progressive representation. Administering figures swoop down to "the chamber, where the good man meets his fate," while in the next scene winged angels escort the soul "just rising to a god" (p. 40). On page 41, one angel looks back to the physical world and to the living friend, now left behind, who bends over the dying man on page 40. Another angel points to heaven as the good man "augustly rears his head" (p. 42) to be greeted by a third angel, who welcomes him to heaven. Blake later pictured a similar event in "The Death of the Good Old Man," one of his illustrations to Robert Blair's *The Grave.*

Title-Page to Night the Third
(Narcissa)
A female figure, who appears from the crescent beneath her feet to have surmounted the trials of this world, is admitted to an eternity of glory: eternity is represented by its usual emblem—a serpent with its extremities united.

Except for the serpent, much of the imagery here is loosely based on a passage (page 46) where Young associates Narcissa with Cynthia, the crescent moon, and "the spheres harmonious." The woman in this design, Narcissa, reaches energetically for apotheosis. Stars are in her hair, and she has risen above the moon, whose sphere is the traditional border between the mutable and immutable worlds. The cres-

cent here is visually and symbolically reminiscent of Time's scythe, particularly as it is represented on page 26. Blake's design also owes a good deal to a passage in Revelation: "And there appeared a great wonder in heaven; a woman clothed with the sun, and the moon under her feet, and upon her head a crown of twelve stars" (Chap. 12, verse 1). In *A Vision of the Last Judgment*, Blake symbolizes "the Church Universal" through similar images: "This State appears like a Female crown'd with stars . . . ; she has the Moon under her feet."

As the "Explanation" points out, the serpent touching its tail, or Ouroboros, is a traditional emblem for eternity. But as H. B. de Groot has shown (see No. 19 in the Bibliography), this motif was also used by emblem writers as a symbol for the endless revolutions of time rather than the freedom from time which is eternity. This would seem to be Blake's meaning here, as it very clearly is in his Ouroboros designs in two of the *Night Thoughts* watercolors never engraved: the verso to this design (*Night Thoughts* 79) and *Night Thoughts* 257. The serpent's coils, like those on the title-page and Plate 10 of Blake's *Europe*, further emphasize time's cyclical and restrictive nature—an "image of infinite / Shut up in finite revolutions" (*Europe*, Pl. 10). In this respect the snake here is like Satan who, in Blake's tempera painting of "Eve Tempted by the Serpent," spirals above Eve and leads her to the disobedience which will bring about the fall into mutability. Blake also associated the moon with Eve in this tempera and in his *Paradise Lost* designs, and with Enitharmon, one of the characters in his Illuminated Books.

Page 46
The folly and danger of pursuing the pleasures of sense as the chief objects of life illustrated by the figure of Death just ready to throw his pall over a young and wanton female.

Everything in the design runs counter to the "Explanation" quoted above. A beautiful young girl flees from her pursuer, just as Oothoon runs from another representative of repression on the title-page to Blake's *Visions of the Daughters of Albion.* Her posture also

suggests that of Mirth in Blake's first design to Milton's *Comus*. A band on her right ankle is a remnant of "reason's chain" which she, in contrast to the poet on page 16, has broken. The delicate bracelets around her wrists also indicate enclosure and the social restraints of wealth and fashion from which this nude girl has for the moment freed herself (see also the necklace of beads or pearls worn by the woman on Plate 6 of Blake's *Europe*, Sabrina's bracelets in the seventh *Comus* design of the Huntington series, and the jewelry draped over the wrists and neck of the figure below the text on Plate 11 of *Jerusalem*). The girl is clearly not an emblem of the senses bound to fallen nature and moral codes, but the liberated senses, "honest, open, seeking / The vigorous joys of morning light" (*Visions of the Daughters of Albion*, Pl. 6). The figure above the girl is not Death as we have come to know him from previous designs, but deadly Reason, about to imprison Sense once again. He is one of Blake's most powerful images in all the *Night Thoughts* illustrations, characterized only by his flowing hair, giant fists, and the frighteningly abstract pattern of his cloak cutting diagonally across the design. All but a few human features are hidden, repressed. Reason's cloak is part of a cluster of Blake's images—veil, shroud, mantle, Covering Cherub, Polypus, mundane shell—all symbolizing the limitations of the fallen world.

Page 49

The author supporting a female figure, and presenting her to the sun; whose aid he seems to solicit, and whose chariot is seen above, surrounded and in some measure obscured by clouds. The artist refers to the circumstance alluded to in the poem, of the author's having attended his step-daughter (Narcissa) who was languishing in a decline, to a more southern climate.

Narcissa sinks weakly into the poet's lap as the sun races towards the sea and dark clouds. The sun is represented by its traditional emblem, Apollo and his steeds, as Blake also pictures them on Plate 14 of his *Job* designs. The "Explanation" tells a good deal about the couple in the foreground, but takes no notice

of the flower on the left. Although the text refers to "Queen Lilies," the plant seems more like a sunflower, its human form "Who countest the steps of the Sun, / Seeking after that sweet golden clime / Where the traveller's journey is done" (Blake's "Ah! Sun-Flower"). Given his usual iconographic consistency, Blake's flower here, like the sunflower in *Songs of Experience*, is a symbol of mortality, "weary of time" and longing for fulfillment.

Page 54

The vale of death, where the Power of darkness broods over his victims, as they are borne down to the grave by the torrent of a sinful life.

This design, illustrating the passage indicated by an asterisk on page 53, is the antithesis to Blake's sunlit watercolor, "The River of Life." Young and old are carried downwards by the dark river, a "channel through the vale of death" (p. 53) and tributary stream to Blake's own waters of materialism (see Plate 12 of *The Book of Urizen*). Two "dying friends" lift their hands in prayer, an old man clutches a cloth over his head, and one victim assumes an outstretched arm posture similar to the swimmer's on page 4. Partly hidden behind the text panel in a way that only adds to his awesomeness, personified Darkness sits "brooding o'er unfinish'd fates." Blake pictured a similarly dark and earth-bound angel with enormous wings on the frontispiece to *America* and, in *The Book of Urizen*, described the "shadow of horror" in a way that suggests this figure in *Night Thoughts*: "unknown, abstracted, / Brooding, secret, the dark power hid" (Pl. 3). "Human thought" walks along the river, her pride turned to meekness as she approaches the huge foot across her path. Blake used this basic design format—a small figure coming upon a giant whose body is obscured by text area— years later on Plate 62 of *Jerusalem*.

Page 55

His guardian angel sent to reprove a mourner for his improper indulgence of sorrow on the tomb of his friend: with one hand the angel

touches the object of his errand, and with the other points to those realms of light in which the deceased was at rest from his labours.

The mourner crouches over into a tight ball, ignoring both spiritual and natural emblems of life after death—the hovering soul pointing heavenwards, and the flowers springing up around the grave. In *The Marriage of Heaven and Hell*, the devil energetically recommends that you should "drive your cart and your plow over the bones of the dead," but here the human form is as lifeless and restricted as death itself. Blake also pictures grave mounds wrapped with briars in his design to "The Garden of Love," in the second and ninth designs for Gray's "Elegy in a Country Churchyard," and in "Prone on the Lowly Grave—She Drops," a rejected design for Blair's *Grave*. The rectilinear tombstone, tilted at a disconcerting angle and divided by a harsh shadow, and the brick or stone tomb in the background emphasize the heavy weight of barren grief.

Page 57

Death with his uplifted dart just disclosing himself to a party of bacchanals; one of whom still continues his intoxicating draught, while his comrades discover symptoms of extreme alarm on the unexpected intrusion of so unwelcome a guest.

Contrary to the "Explanation," the drinkers look less alarmed by Death than "nauseous" from the "sick . . . iteration" of a life spent in debauch. All four block out the organs of perception, either with their hands or through blind drunkenness.

Page 61

As on page 20, an asterisk appears on this unillustrated page. It is likely that the design on page 32 of the watercolors (*Night Thoughts* 107), where the same line is marked, was originally intended for inclusion here but, when excluded, the asterisk was overlooked. In the watercolor, personifications of Age and Disease, the latter holding vials as on page 10 of the engravings, descend through a red atmosphere of blood and veins.

Page 63

To the eye of the righteous the countenance of the King of Terrors is changed into that of the Prince of Peace.

The ancient man seated below the text panel looks a good deal like Death in earlier designs, a resemblance underscored by his prominent knee, giant foot, and the arrows beneath his left elbow. Furthermore, in *Night Thoughts* 108 of the watercolor series, where this same design appears, the passage marked for illustration makes his identity quite clear: "Death, the great Counsellor, who Man inspires / With nobler thought, and fairer deed" (printed on page 62 in the 1797 text reproduced here). Given this poetic context, it would be fair to assume that the scroll contains a statement of man's common fate which will inspire him to better thoughts and deeds. On the other hand, the line marked with an asterisk on page 63 of the engravings suggests that the scroll holds a prophecy of the coming of Christ, "the Prince of Peace" portrayed in the very next engraving. The Hebrew characters on the scroll are too poorly constructed to be easily deciphered, although H. M. Margoliouth (see No. 10 in the Bibliography) has made out words meaning "thou" (twice), "death," "the fire" (twice), and "dust." John Grant (see No. 26 in the Bibliography) reports that a Hebrew scholar has deciphered part of the scroll as "Lord You are Death, YHVH The fire was with the fire / You . . . dust." Both these readings echo the "Death" in the lines marked in the watercolor. The Hebrew letters are also written backwards because Blake failed to take any steps to prevent reversal when he transferred his preliminary design to the copperplate. On Plate 41 of *Jerusalem* Blake purposefully etched mirror-image writing on a scroll, and it is possible that he also had some symbolic intent in allowing the same "accident" to occur here, particularly if the message prophesies an apocalyptic reversal of the ordinary sequence of events. In the watercolor preliminary for this *Night Thoughts* design, the scroll contains only a few brush strokes

running lengthwise, which vaguely suggest letters.

Title-Page to Night the Fourth
(The Christian Triumph)
The resurrection of our Saviour, typical of the resurrection of all his servants from the grave.

Christ, the stigmata clearly visible on His feet and in His side, rises from the tomb in radiant energy, bursting through clouds as He breaks "the bars of death" (p. 76). Attendant angels, one holding a winding sheet, bow in reverence. The same scene, with Christ in much the same posture except for His legs, is pictured in Blake's painting of "The Resurrection," now in the Fogg Museum, and on page 116 of *Vala*. Among the engraved *Night Thoughts* title-pages this design is unique in that the text is not placed within a text panel. This design is the first in the entire watercolor series for which it serves as a frontispiece. Another design was originally selected as the title-page for Night the Fourth.

Page 70
Death, as a huntsman, pursuing with ferocious pleasure his human game.

The personification of Death in Nights One through Three is here replaced by a crowned hunter holding a "tyrant's spear" (p. 72), a figure associated by Morton Paley (see No. 17 in the Bibliography) with Nimrod (Genesis 10:8 and Blake's *Jerusalem*, Pl. 22). His face shows the mixture of idiotic glee and blood lust Blake also gave to the man nailing Christ to the cross in "The King of the Jews," a painting in Lord Glentanar's collection, and to one of the death-heads in the frontispiece to Burger's *Leonora*. The long-haired dogs on the right resemble the hell-hounds in Blake's twenty-fifth Dante design and the dog-faced monster above the text on Plate 4 of *America*. Their short-haired companion forces to earth a victim whose tortured posture is similar to Achan's in Blake's "The Stoning of Achan" in the Tate Gallery.

This is one of the few *Night Thoughts* engravings in which the text panel is a real hindrance, forcing Blake to extend Death's left arm out of all proportion.

Page 72
Two figures, intended to represent Sense and Reason, pointing to another scene of things, and admonishing the author that it is time for him to depart from the present.

Blake pictures Adam and Eve standing before death's door as personifications of "reason" and "sense" respectively. Eve's hair grows into leafy tendrils, identifying her with vegetative nature, and a similar vine partly covers Adam's loins, indicating that he has already fallen. They point to the dust to signify the penalty their fall has imposed on all mankind, including the poet cowering in fear and sneaking off to the right. With their other hands Adam and Eve hold out the answer to the poet's question voiced at the bottom of this page: "What healing hand can pour the balm of peace, / And turn my sight undaunted on the tomb?" Their upraised arms direct us to the portal of death, also pictured on *Night Thoughts* 61 and 118 in the watercolor series. The "Living Form" (Blake's *On Homer's Poetry & On Virgil*) of this Gothic doorway resembles the arch through which the poet fearlessly steps in the frontispiece to Blake's *Jerusalem*. The tomb, where bodies turn to dust, is at the same time the entrance to eternity for the soul, as the hovering angels on the stonework indicate. The poet represented in this *Night Thoughts* design understands only the physical results of death and fails to see its promise of spiritual immortality which, even for Adam and Eve, can offer a "balm of peace" and allow one to look "undaunted on the tomb." Thus the design is an implicit criticism of Edward Young who, in Blake's view, while writing of sin and death all too frequently forgot the visionary themes of salvation and resurrection.

This is the only engraved illustration where Blake violates his usual separation of text and design area to project the poet's head over the lower right corner of the text panel.

Page 73
The Saviour represented in the furnace of affliction, and agonized with torture for the sins of the human race.

Blake illustrates Young's poem very closely here, emphasizing Christ's "healing hand" and feet pierced by the "dire steel." The crown of thorns is visually stressed by the repetition of its outline in the jagged, spiky light of His halo. Both recall the briars binding man to the material world on pages 15 and 16, and twisted about the grave mound on page 55. God willingly submits Himself to human limitations. The flames issuing from the lower border of the design dramatize Christ's passion and prophesy the purgative flames described on page 84: "If a GOD bleeds, he bleeds not for a worm: / I gaze, and as I gaze, my mounting soul / Catches strange fire, eternity! at thee."
In the watercolor design and a proof impression in Blake's *Vala* manuscript Christ's face is seen in profile.

Page 75
The sun as described by the poet, averting his face (which he hides also with his hands) from the shocking spectacle of our Lord's sufferings.

Although there is no asterisk to indicate it, Blake is clearly illustrating the description, marked on the watercolor preliminary (*Night Thoughts* 125), of the sun's reaction to the martyrdom of Christ portrayed in the preceding design: "The sun beheld it—no, the shocking scene / Drove back his chariot, midnight veil'd his face." Both text and design allude metaphorically to the three hours of "darkness over all the land" (Matthew 27:45) on the day of the Crucifixion. The Apollo-like personification of the sun was previously introduced on page 49.

Page 80
A personification of Thunder directing the adoration of the poet to the Almighty in heaven.

The poet stares blankly at the dark and terrifying face of Thunder who, with a single upraised finger, points to heaven, a gesture traditionally associated with prophets. The seascape setting was probably suggested to Blake by Young's reference to "the deep" and the "shore." Thunder's hair stands on end much like the hair of the awesome god on Plate 11 of the *Job* designs where Blake also pictures lightning in the background. Job's god is a false deity, a wrathful and unknown presence like the "nameless HE" described on pages 80 and 81 of the *Night Thoughts*. The representation of Thunder in this design may also be Blake's critical comment on Young's equally horrific and unforgiving god.

Page 86
The exalted views of a good man beyond the pleasures of this life, allegorically described by a figure in the clouds, with one hand fixed in the sky, and with the other pointing to the earth beneath him.

Like the descending figure on page 55 and Adam and Eve on page 72, the young man in this design gestures so as to direct us both to the physical, mortal world and to the immutable heavens. Rain streaks down upon the globe bearing the shadowy suggestion of oceans and continents.

Page 87
Christ represented as the great philanthropist, receiving and instructing all ages and sexes.

All the figures seem oddly subdued and saddened, as if Christ has indeed made "us groan beneath our gratitude" for His self-sacrifice. The halo around His head looks like a many-pointed star, more reminiscent of the nimbus around Thunder's head on page 80 than the radiance streaming from the risen Christ's whole body on the title-page to Night the Fourth. A "great PHILANTHROPIST" who places man under the heavy obligations described by Young is, from Blake's point of view, a misleading conception of God. One child stands in front of Christ in much the same posture as the white child before Christ the Shepherd on the second

plate of Blake's "The Little Black Boy" in *Songs of Innocence*, but even the face of this boy in the *Night Thoughts* looks drawn and joyless.

Page 88
Earnest prayer and intercourse with Heaven compared to the wrestling of Jacob with the angel for a blessing.

As the "Explanation" points out, the line illustrated alludes to Jacob's wrestling with a man and saying "I will not let thee go, except thou bless me" (Genesis 32:26). In the Bible, Jacob's adversary is not specifically called an angel, and thus Blake does not single out one of the combatants as any more spiritual than the other. They both embody the energetic strength of the very sort that Young wishes for in his poetry.

Page 90
The Saviour healing Affliction by a touch with his hand.

The man seems to raise himself from the ground as Christ bends over to touch him. The same scene, with the two figures in postures almost identical to those represented here, is pictured in the frontispiece to Blake's *There Is No Natural Religion*, Second Series, and in the lower right corner of the design accompanying "The Divine Image" in Blake's *Songs of Innocence*. Blake also illustrated "The Chimney Sweeper" in *Innocence* with the same basic motif. Above the text panel in the *Night Thoughts* a butterfly (not present in the watercolor) is suspended over its empty cocoon, a traditional emblem for the sloughing off of the material body which "heals the soul." In a similar fashion, the afflicted man rises from a piece of cloth which, like a discarded winding sheet, now lies on the ground.

Page 92
The harmony between Faith and Reason, illustrated by Faith writing down the dictates of Reason.

A faith bound to reason was for Blake no faith at all. Rather than the "harmony" of the "Explanation," Blake shows an undue subservience of "daughter" Faith at the steps of "mother" Reason. Faith's head is awkwardly twisted upwards and her hair partly restrained by a knot. One suspects that any messages she could record with her quill on the writing tablet beneath her right hand would be equally strained and limited. The "impartial scale" held in Reason's upraised right hand indicates that she makes quantitative rather than spiritual judgments. Her giant foot and prominent knee remind us of Death in other *Night Thoughts* designs (see the title-page to Night the First and page 7) and the figure of Urizen, his name itself a pun on "your reason," in Blake's Illuminated Books. The crown and the spiky pattern around Reason's neck associates her with the monarchs in earlier *Night Thoughts* illustrations and with tyrants similarly adorned throughout Blake's art.

The design is arranged on the page as if Reason were weighing the text panel. As the level bar indicates, Young's lines weigh no more than the empty pan on the other end of the scale.

Page 93
Angels retiring in grief and wonder from their charge of a determined infidel.

The resolute disbeliever refuses to accept spiritual presences, as his outstretched left hand indicates, and prefers to stare blankly off into space. The same kind of rejection scene is pictured in the design to "The Angel" in Blake's *Songs of Experience* where a melancholic woman pushes a winged cupid from her. The angels "tremble" with "grief" (the figure nearer the right margin) and "wonder" (the figure nearer the text panel).

Page 95
A personification of Truth, as she is represented by the poet, bursting on the last moments of the sinner " in thunder and in flame."

Truth springs "from her cavern in the soul's abyss" and points to heaven with both hands. The "thunder" from which she "bursts," the lightning (not present in the watercolor), her piercing eyes, and the circular mouth all recall the Thunder god on page 80. Although clearly feminine, Truth's energy, serpentine hair, and fiery environment associate her with Orc, the burning, howling youth of revolution in Blake's Illuminated Books, particularly as he is represented on Plate 10 of *America*. In *Europe* (Pl. 4), it is Orc who is asked to "Arise . . . from [his] deep den!"

BIBLIOGRAPHY

Studies of Blake's *Night Thoughts* Designs

Most of the books and essays listed below deal primarily with the watercolors rather than the engravings reproduced here.

1. T. W. Hanson. "Edwards of Halifax. Book Sellers, Collectors and Book-Binders," *Halifax Guardian*, Dec. 21, 1912. Reprinted in Hanson, *Papers, Reports, &c. Read before the Halifax Antiquarian Society, 1912*. Halifax [1913], p. 171.

Hanson quotes Thomas Edwards's description of the *Night Thoughts* watercolors from his sale catalogues of 1821 and 1826. Hanson also writes of the Edwards-Blake relationship in *The* [London] *Times Literary Supplement*. Aug. 8, 1942, p. 396.

2. Edward Bulwer-Lytton. "Conversations with an Ambitious Student in Ill Health," *New Monthly Magazine*, 29 (Dec., 1830), 511–19, esp. 518–19. Reprinted in *The Student*. London: Saunders & Otley, 1835, Vol. II, pp. 152–55, and in the edition of his *Miscellaneous Prose Works* of 1868.

Bulwer-Lytton's personal responses to the *Night Thoughts* designs are also reprinted in No. 18 below, pp. 401–2.

3. J. C. C. [J. Comyns Carr]. "William Blake," *Cornhill Magazine*, 31 (1875), 721–36, esp. 728–35. Reprinted in *Living Age*, 126 (1875), 67–77.

This early essay is still a valuable critical appreciation of Blake's method as an illustrator in the *Night Thoughts* designs.

4. Frederic James Shields. "Descriptive Notes of the Designs to Young's 'Night Thoughts.'" In Alexander Gilchrist, *Life of William Blake*. Second ed. London: Macmillan, 1880, Vol. II, pp. [289]–307.

Descriptive and at times interpretive notes on 119 of the watercolor designs.

5. Adeline M. Butterworth. *William Blake, Mystic*. Liverpool: Liverpool Booksellers; and London: Simpkin, Marshall, Hamilton, Kent, 1911, pp. 10–[18].

Poor-quality reproductions of the engravings for the first two Nights with the "Explanation of the Engravings" and a few uninformative comments.

6. *Illustrations to Young's Night Thoughts Done in Water-Colour by William Blake*. With an Introductory Essay by Geoffrey Keynes. Cambridge, Mass.: Harvard Univ. Press, 1927.

Reproduced, with a brief commentary by Keynes, are thirty of the watercolors, five in beautiful color. Keynes's introduction is reprinted in his *Blake Studies* (London: Hart-Davis, 1949), pp. 56–66 (with minor revisions) and second ed. (Oxford: Clarendon Press, 1971), pp. 50–58 (with further revisions and additional information on colored copies of the engravings).

7. Philippe Soupault. *William Blake*. Paris: Editions Rieder, 1928, pp. 31–33. Translated by J. Lewis May. London: Bodley Head, 1928, pp. 36–37.

Unlike most commentators, Soupault believes that Young was a great poet, but that Blake felt restrained in engraving his illustrations.

8. W. E. Moss. "The Coloured Copies of Blake's 'Night Thoughts,'" *Blake Newsletter*, 2 (Sept., 1968), 19–23.

A brief article, written in about 1942, with a census of colored copies of the engravings. The census is brought up to date in No. 15 below.

9. G. E. Bentley, Jr. "Blake and Young," *Notes & Queries*, 199 (1954), 528–30.

The influence of Young's *Night Thoughts* on Blake's Epilogue to *For the Sexes: The Gates of Paradise*.

10. H. M. Margoliouth. "Blake's Drawings for Young's *Night Thoughts*," *Review of English Studies*, N.S. 5 (1954), 47–54. Reprinted in *The Divine Vision: Studies in the Poetry and Art of William Blake*. Ed. Vivian de Sola Pinto. London: Gollancz, 1957, pp. 193–204.

An informative essay with some comparisons between the watercolors and engravings.

11. Robert R. Wark. "A Minor Blake Conundrum," *Huntington Library Quarterly*, 5 (1957), 83–86.

A discussion of a curious watercolor on vellum which is a mirror image of one of the *Night Thoughts* watercolors never engraved.

12. Jean H. Hagstrum. *William Blake Poet and Painter*. Chicago & London: Univ. of Chicago Press, 1964, pp. 121–23.

Brief, intelligent comments, stressing the similarities between the figures in the *Night Thoughts* designs and the characters in Blake's own mythic poetry.

13. S. Foster Damon. "Young." In *A Blake Dictionary*. Providence, R.I.: Brown Univ. Press, 1965, pp. 455–56.

On Blake's method as an illustrator and Young's influence on Blake.

14. Michael J. Tolley. "*The Book of Thel* and *Night Thoughts*," *Bulletin of the New York Public Library*, 69 (1965), 375–85.

Young's poem as a source for *The Book of Thel*, one of Blake's Illuminated Books written several years before the *Night Thoughts* designs.

15. G. E. Bentley, Jr. "A Census of Coloured Copies of Young's *Night Thoughts* (1797)," *Blake Newsletter*, 2 (Dec., 1968), 41–45.

A revision and updating of the Moss census (No. 8 above).

16. John Beer. *Blake's Visionary Universe*. Manchester: Manchester Univ. Press, 1969, pp. 264–67, 343–52.

Interesting general observations, but questionable on specific details in designs. Beer also proposes that the *Night Thoughts* proofs used for the *Vala* manuscript are symbolically related to Blake's poem.

17. Morton D. Paley. "Blake's *Night Thoughts:* An Exploration of the Fallen World." In *William Blake: Essays for S. Foster Damon*. Ed. Alvin H. Rosenfeld. Providence, R.I.: Brown Univ. Press, 1969, pp. 131–57.

An important essay on the relationships between the *Night Thoughts* designs and Blake's own poetry.

18. G. E. Bentley, Jr. *Blake Records*. Oxford: Clarendon Press, 1969, pp. 50–52, 56–57, 401–2.

Quotes the "Prospectus" for Edwards's edition, parts of the "Advertisement," the entries in Joseph Farington's diary concerning the *Night Thoughts* designs, and Bulwer-Lytton's article (see No. 2 above).

19. H. B. de Groot. "The Ouroboros and the Romantic Poets," *English Studies*, 50 (Oct., 1969), 553–64.

On Blake's use of the traditional emblem of a snake holding its tail in its mouth in the *Night Thoughts* designs and elsewhere.

20. John E. Grant. "Envisioning the First *Night Thoughts*." In *Blake's Visionary Forms Dramatic*. Ed. David V. Erdman and John E. Grant. Princeton: Princeton Univ. Press, 1970, pp. 304–35.

A close study of the watercolor designs to the first Night, stressing comparisons between repeated motifs and their significance throughout Blake's work as both poet and painter.

21. Thomas H. Helmstadter. "Blake's *Night Thoughts:* Interpretations of Edward Young," *Texas Studies in Literature and Language*, 12 (1970), 27–54. Reprinted with minor revisions and additional illustrations in *The Visionary Hand: Essays for the Study of William Blake's Art and Aesthetics*. Ed. Robert N. Essick. Los Angeles: Hennessey & Ingalls, 1973, pp. 381–418.

An important essay on Blake's projection of his own symbolism into the designs to form a critique of Young's poetics.

22. ———. "Blake and Religion: Iconographical Themes in the *Night Thoughts*," *Studies in Romanticism*, 10 (1971), 199–212.

On selected designs as revelations of Blake's views on religion.

23. ———. "Blake and the Age of Reason: Spectres in the *Night Thoughts*," *Blake Studies*, 5 (1972), 105–39.

On selected designs as revelations of Blake's views on the eighteenth-century advocacy of reason.

24. Roger R. Easson and Robert N. Essick. *William Blake: Book Illustrator*. Volume I: Plates Designed and Engraved by Blake. Normal, Illinois: American Blake Foundation, 1972, pp. 13–28, Pls. IV-1 to IV-43.

A bibliographic description of the 1797 *Night Thoughts* volume and a catalogue and reproduction of the engravings.

25. Robert N. Essick. "Blake and the Traditions of Reproductive Engraving," *Blake Studies*, 5 (1972), 59–103, esp. 72, 103.

A brief comparison of Blake's engraving technique in the *Night Thoughts* and *Job* designs.

26. John E. Grant. "Visions in *Vala*: A Consideration of Some Pictures in the Manuscript." In *Blake's Sublime Allegory: Essays on The Four Zoas, Milton, Jerusalem*. Ed. Stuart Curran and Joseph Anthony Wittreich, Jr. Madison, Wisconsin: Univ. of Wisconsin Press, 1973, pp. 141–202.

This article proposes some ways in which those *Night Thoughts* engravings used as leaves in the *Vala* manuscript may be connected with the text or may have influenced the sketches Blake made on other leaves in *Vala*.

27. *William Blake's Designs for Edward Young's Night Thoughts: A Complete Edition*. Ed. John E. Grant, Edward J. Rose, and Michael J. Tolley, with the assistance of David V. Erdman. Oxford: Clarendon Press, forthcoming.

This complete reproduction in two volumes of the 537 *Night Thoughts* watercolors, now in the British Museum, will have about 80 color plates including samples from colored engraved copies. Also reproduced will be preliminary sketches, all the proofs, and the engravings. It will be followed by three volumes of commentary written by the editors.

THE COMPLAINT,

AND

THE CONSOLATION;

OR,

NIGHT THOUGHTS,

BY

EDWARD YOUNG, LL.D.

————*fatis contraria fata rependens.*

V IRG.

LONDON:

PRINTED BY R. NOBLE,

FOR R. EDWARDS, No. 142, BOND-STREET,

M DCC XCVII.

ADVERTISEMENT.

IN an age like the present of literature and of taste, in which
the arts, fostered by the general patronage, have attained to
growth beyond the experience of former times, no apology can
be necessary for offering to the publick an embellished edition of
an english classick; or for giving to the great work of Young
some of those advantages of dress and ornament which have
lately distinguished the immortal productions of Shakspeare and
of Milton.

But it was not solely to increase the honours of the british
press, or to add a splendid volume to the collections of the
wealthy, that the editor was induced to adventure on the present
undertaking. Not uninfluenced by professional, he acted also
under the impulse of higher motives; and when he selected the

Night Thoughts for the subject of his projected decoration, he wished to make the arts, in their most honourable agency, subservient to the purposes of religion; and by their allurements to solicit the attention of the great for an enforcement of religious and moral truth, which can be ineffectual only as it may not be read.

From its first appearance in the world, this poem has united the suffrages of the criticks in the acknowledgment of its superior merit. If it has not been allowed to be the " sine labe " monstrum," it has been determined to be a composition of great and predominating excellence. Some dusky spots might be observed to float on its surface, but the mass in the whole was confessed to be luminous and burning : something in short might be objected to the judgment or the taste of Young; but the most daring spirit of detraction could never withhold from him the praise of powerful language; of deep knowledge; of a vivid and excursive imagination ; of a mind at once vigorous and comprehensive, which could discriminate with the rectitude of philosophy, and adorn with the colouring of poetry. In this work, indeed, which in its structure is original, and in which, to use the author's own words, " the narrative is short, and the moral- " ity arising from it forms the bulk of the poem," the beauties are too numerous to admit of individual notice, and too striking to require particular distinction. In every page the reader finds

his attention held captive by poetry in its boldest and most successful exertion: every where is his imagination soothed with pleasing, or enlarged with grand imagery: every where does he see fancy binding flowers round the altar of truth, while reason in aweful pomp is presenting her sacrifice to heaven.

The principal charges which have been urged against this poem, and which in some degree may have affected its popularity, are the dark tints of its painting; and the obscurities which occasionally occur in it to retard the progress of the reader. With respect to the first of these objections, it must be admitted that, in the work before us, the great poet of christianity offers no flattery to the passions; and, conscious of the demands and dignity of his subject, is less careful to please than to improve; to conciliate than to impress and awe. To court the smile of thoughtless levity was altogether incompatible with the theme which he had chosen. The muse who

" To day's soft-eyed sister paid her court;"

who took her nightly walk among the tombs; and whose office it was to insist on the final termination of the pleasures, and the pride; the expectations, and the pursuits which refer only to this sublunary existence, must necessarily be a foe to that " laughter " which is mad;" and could not reasonably hope to be a favourite with the frivolous, the profligate, or the criminal: to her lighter sisters, who sport beneath the beams of the sun, and are con-

versant in the ranks of common life, must she resign the task of trivial and general entertainment: she presents to the eye nothing

> " But solemn counsels, images of awe,

> " Truths which eternity lets fall on man," &c.

With these, however, she must always obtain regard from the reflecting and the wise—from all, possessing the feelings proper to a creature like man, who, placed amid the difficulties and dangers of a state of moral trial, must soon render an account on which his everlasting condition is to depend. The gloominess of the NIGHT THOUGHTS respects, indeed, only the sense, and vanishes from the reason—it is nothing more than the mitigated day of a majestick grove, which invites to meditation, and after a short interval of shade opens into strong and full light.

From the imputation of obscurity it may not, perhaps, be equally easy to vindicate the pages of our author. Throughout the poem there prevails a studied and ambitious brevity of expression; the source of much vigour, but the source also of occasional obscurity. The thought in some passages over-informs the language, and " more is actually meant than meets the " ear:" in some passages, while he is conscious of the connexion of his own sense, the poet seems not sufficiently careful to disclose it to his readers; and in some again, though it must be allowed in very few, he appears not to have been perfectly clear

in the distinction and developement of his ideas; or to have involved them in a perplexed and entangled construction of sentence. Instances, however, of obscurity from these latter causes are extremely rare, and may as frequently perhaps be discovered in the writings of our most correct poets, as in the NIGHT THOUGHTS. But if to this fault, on its admission, be added some others which may be discoverable by critical observation, the whole mass of delinquency will be comparatively small; and can be regarded as scarcely of any account when balanced against the weighty and shining merits, poetical and moral, of this noble composition. It may here be proper to remark that this is acknowledged, by the most determined *advocates of rhyme,* to be one of the few poems in our language in which blank verse affords general pleasure, and " could not be changed for rhyme " but with disadvantage." *

On the immediate subject of the present edition of this valuable work the editor has only to say that he has shrunk from no expence in the preparing of it; and that to make it as worthy in every respect as possible of the public favour has been the object of his particular and solicitous attention. It has been regarded by him, indeed, not as a speculation of advantage, but as an indulgence of inclination;—as an undertaking in which

* Johnson's Lives of the Poets.

fondness and partiality would not permit him to be curiously accurate in adjusting the estimate of profit and loss. If this edition, therefore, of the NIGHT THOUGHTS be found deficient in any essential requisite to its perfection, the circumstance must be imputed to some other cause, than to the œconomy or the negligence of the editor.

Of the merit of Mr. Blake in those designs which form not only the ornament of the page, but, in many instances, the illustration of the poem, the editor conceives it to be unnecessary to speak. To the eyes of the discerning it need not be pointed out; and while a taste for the arts of design shall continue to exist, the original conception, and the bold and masterly execution of this artist cannot be unnoticed or unadmired.

Dec. 22d. 1796.

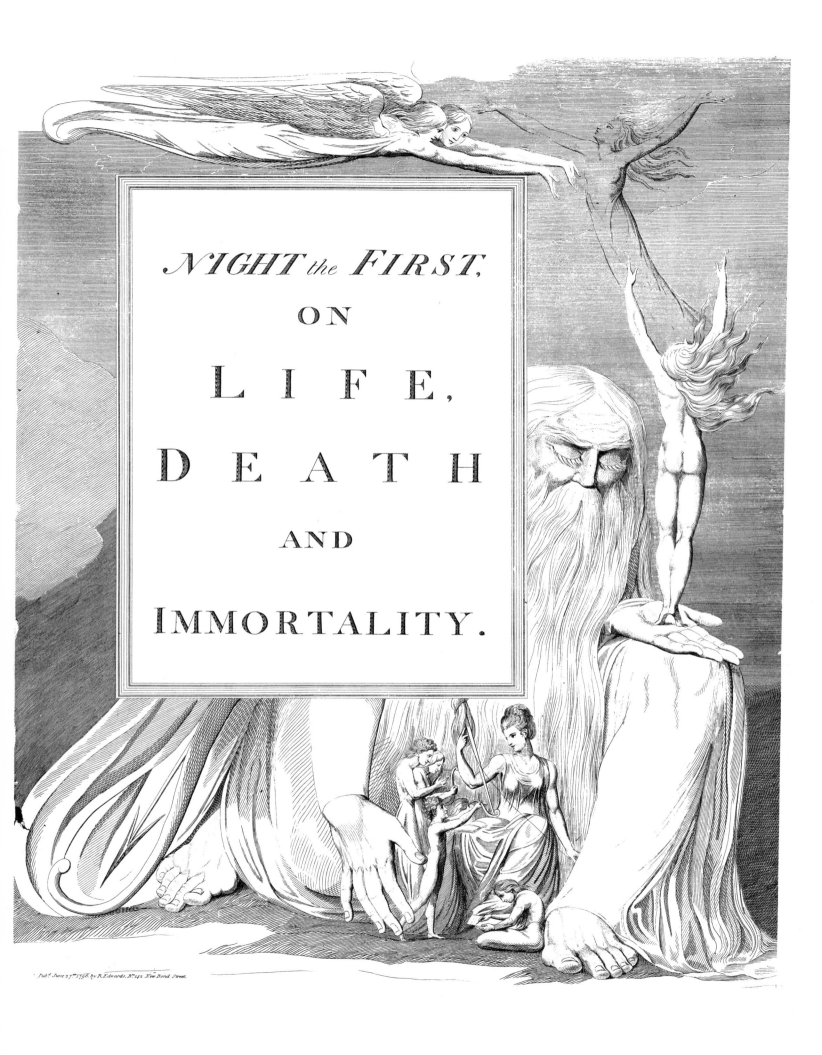

NIGHT the FIRST,

ON

LIFE,

DEATH

AND

IMMORTALITY.

Pub.d June 27.th 1796. by R.Edwards. N.o 142 New Bond Street.

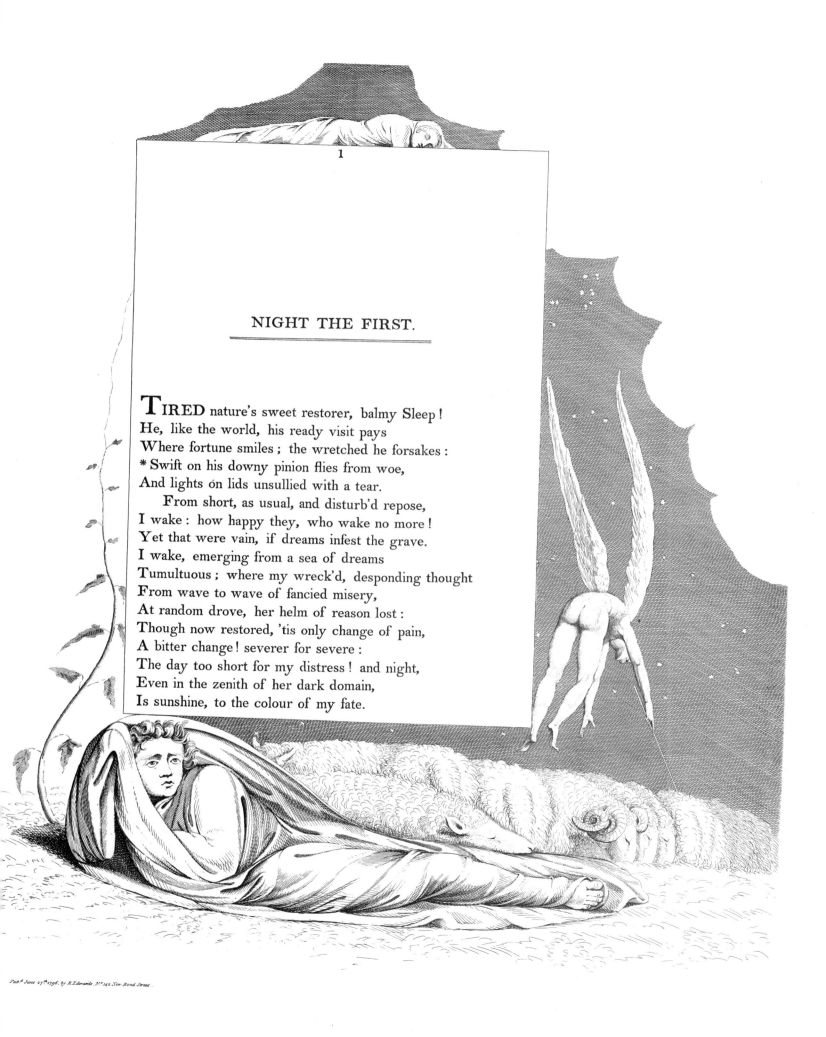

1

NIGHT THE FIRST.

TIRED nature's sweet restorer, balmy Sleep!
He, like the world, his ready visit pays
Where fortune smiles; the wretched he forsakes:
* Swift on his downy pinion flies from woe,
And lights on lids unsullied with a tear.
　　　From short, as usual, and disturb'd repose,
I wake: how happy they, who wake no more!
Yet that were vain, if dreams infest the grave.
I wake, emerging from a sea of dreams
Tumultuous; where my wreck'd, desponding thought
From wave to wave of fancied misery,
At random drove, her helm of reason lost:
Though now restored, 'tis only change of pain,
A bitter change! severer for severe:
The day too short for my distress! and night,
Even in the zenith of her dark domain,
Is sunshine, to the colour of my fate.

Pub.ᵈ June 27ᵗʰ 1796, by R.Edwards, N.º 142 New Bond Street.

Night, sable goddess! from her ebon throne,
In rayless majesty, now stretches forth
Her leaden sceptre o'er a slumb'ring world:
Silence, how dead! and darkness, how profound!
Nor eye, nor list'ning ear an object finds;
Creation sleeps. 'Tis, as the general pulse
Of life stood still, and nature made a pause;
An aweful pause! prophetick of her end.
And let her prophecy be soon fulfill'd;
Fate! drop the curtain; I can lose no more.
　　　Silence, and Darkness! solemn sisters! twins
From ancient night, who nurse the tender thought
To reason, and on reason build resolve,
That column of true majesty in man,
Assist me: I will thank you in the grave—
The grave, your kingdom: there this frame shall fall
A victim sacred to your dreary shrine:
But what are ye? THOU, who didst put to flight
Primeval silence, when the morning stars,
Exulting, shouted o'er the rising ball;
O THOU! whose word from solid darkness struck
That spark, the sun; strike wisdom from my soul—
My soul, which flies to THEE, her trust, her treasure,
As misers to their gold, while others rest.
　　　Through this opaque of nature, and of soul,
This double night, transmit one pitying ray,
To lighten, and to cheer: O lead my mind,
A mind that fain would wander from its woe,
Lead it through various scenes of life, and death;
And from each scene, the noblest truths inspire:

Nor less inspire my conduct, than my song;
Teach my best reason, reason; my best will
Teach rectitude; and fix my firm resolve
Wisdom to wed, and pay her long arrear:
Nor let the phial of thy vengeance, pour'd
On this devoted head, be pour'd in vain.

 The bell strikes one! We take no note of time,
But from its loss: to give it then a tongue,
Is wise in man. As if an angel spoke,
I feel the solemn sound. If heard aright,
It is the knell of my departed hours:
Where are they? With the years beyond the flood:
It is the signal that demands dispatch:
How much is to be done! My hopes and fears
Start up alarm'd, and o'er life's narrow verge
Look down—On what? A fathomless abyss!
A dread eternity! how surely mine!
And can eternity belong to me,
Poor pensioner on the bounties of an hour?

 How poor, how rich, how abject, how august,
How complicate, how wonderful is man!
How passing wonder HE, who made him such!
Who centred in our make such strange extremes?
From different natures marvellously mix'd,
Connexion exquisite of distant worlds!
Distinguish'd link in being's endless chain!
Midway from nothing to the Deity!
A beam ethereal, sullied, and absorb'd!
Though sullied and dishonour'd, still divine!
Dim miniature of greatness absolute!

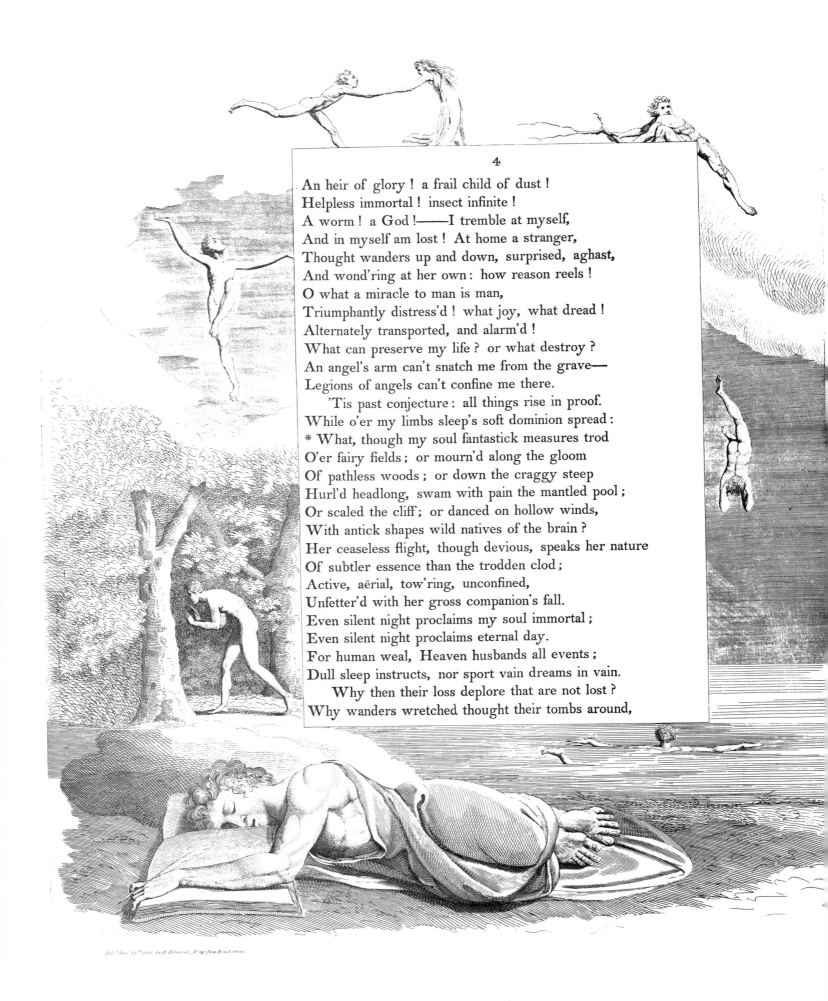

An heir of glory ! a frail child of dust !
Helpless immortal ! insect infinite !
A worm ! a God !——I tremble at myself,
And in myself am lost ! At home a stranger,
Thought wanders up and down, surprised, aghast,
And wond'ring at her own: how reason reels !
O what a miracle to man is man,
Triumphantly distress'd ! what joy, what dread !
Alternately transported, and alarm'd !
What can preserve my life ? or what destroy ?
An angel's arm can't snatch me from the grave——
Legions of angels can't confine me there.
　　'Tis past conjecture: all things rise in proof.
While o'er my limbs sleep's soft dominion spread:
* What, though my soul fantastick measures trod
O'er fairy fields ; or mourn'd along the gloom
Of pathless woods ; or down the craggy steep
Hurl'd headlong, swam with pain the mantled pool ;
Or scaled the cliff; or danced on hollow winds,
With antick shapes wild natives of the brain ?
Her ceaseless flight, though devious, speaks her nature
Of subtler essence than the trodden clod ;
Active, aërial, tow'ring, unconfined,
Unfetter'd with her gross companion's fall.
Even silent night proclaims my soul immortal ;
Even silent night proclaims eternal day.
For human weal, Heaven husbands all events ;
Dull sleep instructs, nor sport vain dreams in vain.
　　Why then their loss deplore that are not lost ?
Why wanders wretched thought their tombs around,

Pub d June 27 th 1796. by R. Edwards, N°142 New Bond Street.

In infidel distress? Are angels there?
Slumbers, raked up in dust, ethereal fire?
 They live! they greatly live a life on earth
Unkindled, unconceived! and from an eye
Of tenderness, let heavenly pity fall
On me, more justly number'd with the dead.
This is the desart, this the solitude:
How populous, how vital, is the grave!
This is creation's melancholy vault,
The vale funereal, the sad cypress gloom;
The land of apparitions, empty shades!
All, all on earth is shadow, all beyond
Is substance: the reverse is folly's creed:
How solid all, where change shall be no more!
 This is the bud of being, the dim dawn,
The twilight of our day, the vestibule;
Life's theatre as yet is shut, and death,
Strong death alone can heave the massy bar,
This gross impediment of clay remove,
And make us, embryos of existence, free.
From real life, but little more remote
Is he, not yet a candidate for light,
The future embryo, slumb'ring in his sire:
Embryos we must be, till we burst the shell,
Yon ambient azure shell, and spring to life,
The life of gods, O transport! and of man.
 Yet man, fool man! here buries all his thoughts;
Inters celestial hopes without one sigh:
Pris'ner of earth, and pent beneath the moon,
Here pinions all his wishes; wing'd by heaven

To fly at infinite ; and reach it there,
Where seraphs gather immortality
On life's fair tree, fast by the throne of GOD.
What golden joys ambrosial clust'ring glow
In HIS full beam, and ripen for the just—
Where momentary ages are no more !
Where time, and pain, and chance, and death expire !
And is it in the flight of threescore years,
To push eternity from human thought,
And smother souls immortal in the dust ?
A soul immortal, spending all her fires,
Wasting her strength in strenuous idleness,
Thrown into tumult, raptured, or alarm'd
At aught this scene can threaten, or indulge,
Resembles ocean into tempest wrought,
To waft a feather, or to drown a fly.
 Where falls this censure ? It o'erwhelms myself:
How was my heart incrusted by the world !
O how self-fetter'd was my groveling soul !
How, like a worm, was I wrapt round and round
In silken thought, which reptile fancy spun ;
Till darken'd reason lay quite clouded o'er
With soft conceit of endless comfort here,
Nor yet put forth her wings to reach the skies !
 Night-visions may befriend, as sung above:
Our waking dreams are fatal: how I dreamt
Of things impossible ! could sleep do more ?
Of joys perpetual in perpetual change !
Of stable pleasures on the tossing wave !
Eternal sunshine in the storms of life !

How richly were my noontide trances hung
With gorgeous tapestries of pictured joys,
Joy behind joy, in endless perspective!
* Till at Death's toll, whose restless iron tongue
Calls daily for his millions at a meal,
Starting I 'woke, and found myself undone.
Where's now my frenzy's pompous furniture?
The cobweb'd cottage, with its ragged wall
Of mould'ring mud, is royalty to me:
The spider's most attenuated thread,
Is cord, is cable, to man's tender tie
On earthly bliss; it breaks at every breeze.
 O ye blest scenes of permanent delight!
Full, above measure! lasting, beyond bound!
A perpetuity of bliss, is bliss.
Could you, so rich in rapture, fear an end,
That ghastly thought would drink up all your joy,
And quite unparadise the realms of light.
Safe are you lodged above these rolling spheres;
The baleful influence of whose giddy dance
Sheds sad vicissitude on all beneath.
Here teems with revolutions every hour,
And rarely for the better; or the best,
More mortal than the common births of fate:
Each moment has its sickle, emulous
Of time's enormous scythe, whose ample sweep
Strikes empires from the root; each moment plays
His little weapon in the narrower sphere
Of sweet domestick comfort, and cuts down
The fairest bloom of sublunary bliss.

Pub.d June. 27. 1796. by R. Edwards. N.o 142 New Bond Street.

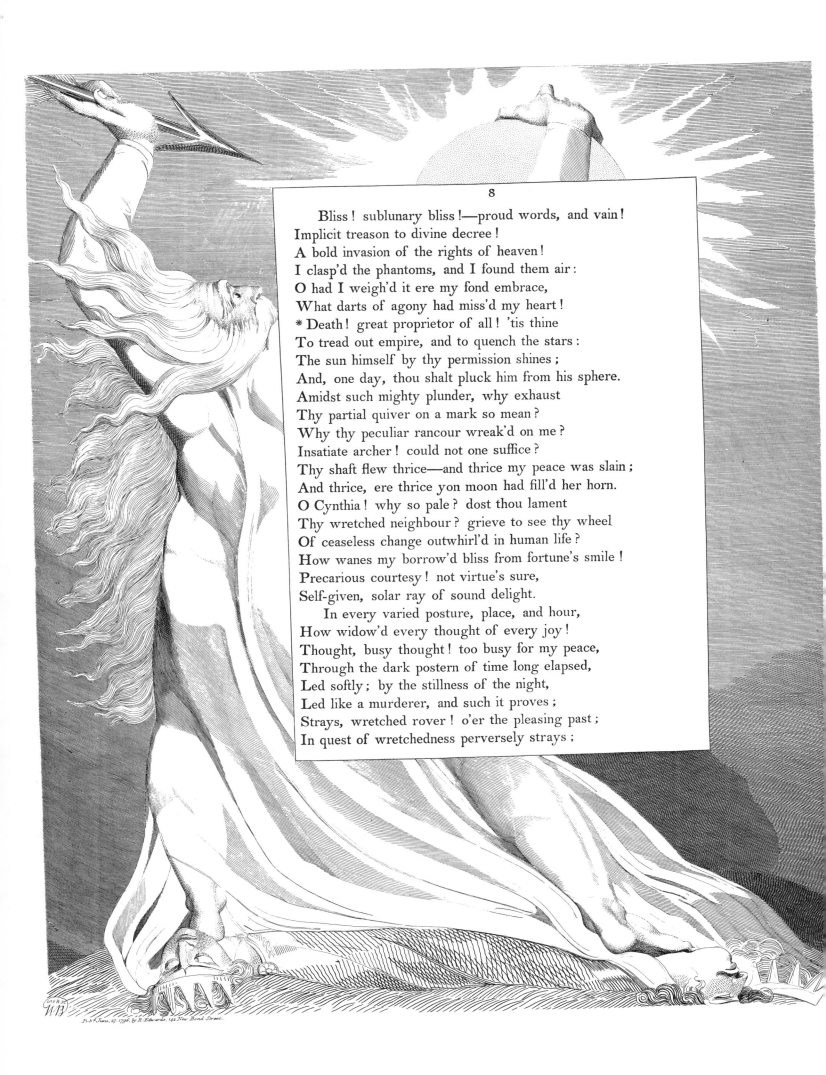

8

Bliss! sublunary bliss!—proud words, and vain!
Implicit treason to divine decree!
A bold invasion of the rights of heaven!
I clasp'd the phantoms, and I found them air:
O had I weigh'd it ere my fond embrace,
What darts of agony had miss'd my heart!
* Death! great proprietor of all! 'tis thine
To tread out empire, and to quench the stars:
The sun himself by thy permission shines;
And, one day, thou shalt pluck him from his sphere.
Amidst such mighty plunder, why exhaust
Thy partial quiver on a mark so mean?
Why thy peculiar rancour wreak'd on me?
Insatiate archer! could not one suffice?
Thy shaft flew thrice—and thrice my peace was slain;
And thrice, ere thrice yon moon had fill'd her horn.
O Cynthia! why so pale? dost thou lament
Thy wretched neighbour? grieve to see thy wheel
Of ceaseless change outwhirl'd in human life?
How wanes my borrow'd bliss from fortune's smile!
Precarious courtesy! not virtue's sure,
Self-given, solar ray of sound delight.
　　In every varied posture, place, and hour,
How widow'd every thought of every joy!
Thought, busy thought! too busy for my peace,
Through the dark postern of time long elapsed,
Led softly; by the stillness of the night,
Led like a murderer, and such it proves;
Strays, wretched rover! o'er the pleasing past;
In quest of wretchedness perversely strays;

Pub.d June, 27, 1796, by R. Edwards, 142 New Bond Street.

And finds all desert now; and meets the ghosts
Of my departed joys, a numerous train!
I rue the riches of my former fate:
Sweet comfort's blasted clusters I lament:
I tremble at the blessings once so dear;
And every pleasure pains me to the heart.

 Yet why complain? or why complain for one?
Hangs out the sun his lustre but for me,
The single man? are angels all beside?
I mourn for millions—'tis the common lot:
In this shape, or in that, has fate entail'd
The mother's throes on all of woman born,
Not more the children, than sure heirs of pain.

 War, famine, pest, volcano, storm, and fire,
Intestine broils, oppression, with her heart
Wrapp'd up in triple brass, besiege mankind:
GOD's image, disinherited of day,
Here, plunged in mines, forgets a sun was made;
There, beings, deathless as their haughty lord,
Are hammer'd to the galling oar for life;
And plough the winter's wave, and reap despair:
Some, for hard masters broken under arms,
In battle lopp'd away, with half their limbs
Beg bitter bread through realms their valour saved,
If so the tyrant, or his minions doom.
Want and incurable disease, fell pair!
On hopeless multitudes remorseless seize
At once; and make a refuge of the grave:
How groaning hospitals eject their dead!
What numbers groan for sad admission there!

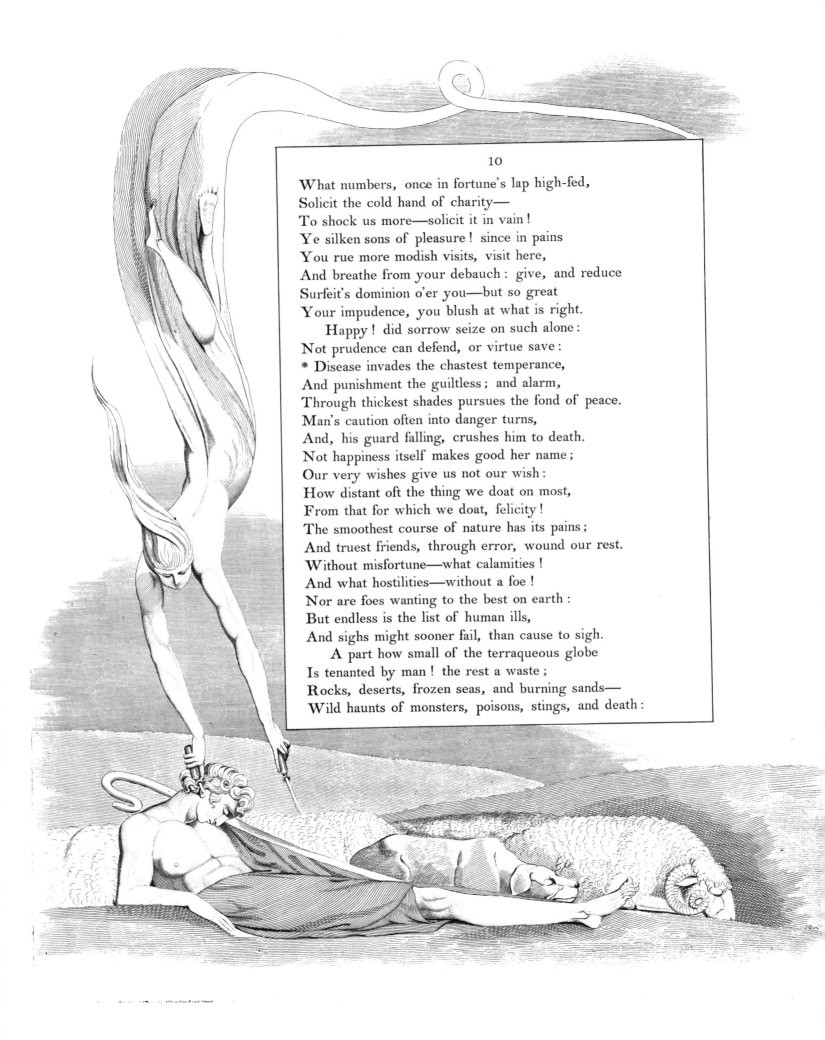

10

What numbers, once in fortune's lap high-fed,
Solicit the cold hand of charity—
To shock us more—solicit it in vain!
Ye silken sons of pleasure! since in pains
You rue more modish visits, visit here,
And breathe from your debauch: give, and reduce
Surfeit's dominion o'er you—but so great
Your impudence, you blush at what is right.
 Happy! did sorrow seize on such alone:
Not prudence can defend, or virtue save:
* Disease invades the chastest temperance,
And punishment the guiltless; and alarm,
Through thickest shades pursues the fond of peace.
Man's caution often into danger turns,
And, his guard falling, crushes him to death.
Not happiness itself makes good her name;
Our very wishes give us not our wish:
How distant oft the thing we doat on most,
From that for which we doat, felicity!
The smoothest course of nature has its pains;
And truest friends, through error, wound our rest.
Without misfortune—what calamities!
And what hostilities—without a foe!
Nor are foes wanting to the best on earth:
But endless is the list of human ills,
And sighs might sooner fail, than cause to sigh.
 A part how small of the terraqueous globe
Is tenanted by man! the rest a waste;
Rocks, deserts, frozen seas, and burning sands—
Wild haunts of monsters, poisons, stings, and death:

Such is earth's melancholy map! but, far
More sad, this earth is a true map of man:
So bounded are its haughty lord's delights
To woe's wide empire; where deep troubles toss,
Loud sorrows howl, envenom'd passions bite,
Ravenous calamities our vitals seize,
And threatening fate wide opens to devour.
 What then am I, who sorrow for myself?
In age, in infancy, from others aid
Is all our hope—to teach us to be kind—
That, nature's first, last lesson to mankind:
The selfish heart deserves the pain it feels;
More generous sorrow, while it sinks, exalts;
And conscious virtue mitigates the pang:
Nor virtue, more than prudence, bids me give
Swoln thought a second channel; who divide,
They weaken too the torrent of their grief.
Take then, O world! thy much-indebted tear:
How sad a sight is human happiness
To those, whose thought can pierce beyond an hour!
O thou! whate'er thou art, whose heart exults!
Wouldst thou I should congratulate thy fate?
I know thou wouldst; thy pride demands it from me:
Let thy pride pardon, what thy nature needs—
The salutary censure of a friend.
Thou happy wretch! by blindness thou art blest;
By dotage dandled to perpetual smiles:
Know, smiler, at thy peril art thou pleased;
Thy pleasure is the promise of thy pain:
Misfortune, like a creditor severe,

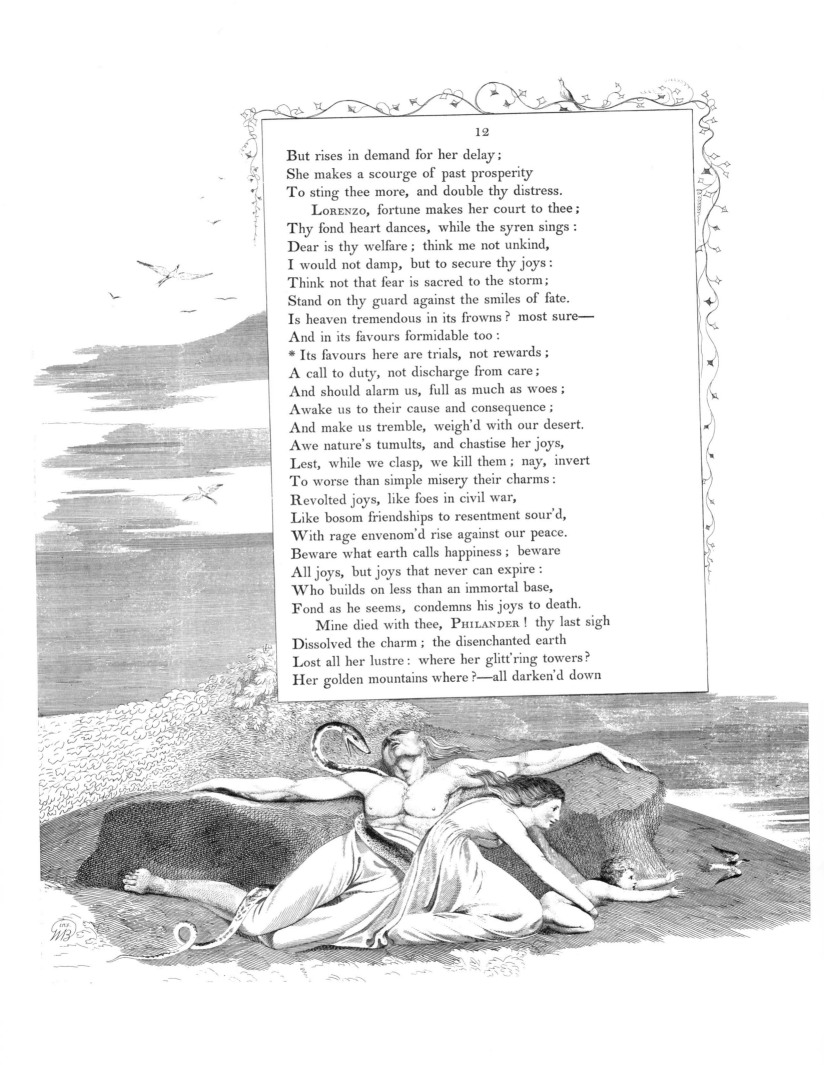

But rises in demand for her delay;
She makes a scourge of past prosperity
To sting thee more, and double thy distress.

 LORENZO, fortune makes her court to thee;
Thy fond heart dances, while the syren sings:
Dear is thy welfare; think me not unkind,
I would not damp, but to secure thy joys:
Think not that fear is sacred to the storm;
Stand on thy guard against the smiles of fate.
Is heaven tremendous in its frowns? most sure—
And in its favours formidable too:
* Its favours here are trials, not rewards;
A call to duty, not discharge from care;
And should alarm us, full as much as woes;
Awake us to their cause and consequence;
And make us tremble, weigh'd with our desert.
Awe nature's tumults, and chastise her joys,
Lest, while we clasp, we kill them; nay, invert
To worse than simple misery their charms:
Revolted joys, like foes in civil war,
Like bosom friendships to resentment sour'd,
With rage envenom'd rise against our peace.
Beware what earth calls happiness; beware
All joys, but joys that never can expire:
Who builds on less than an immortal base,
Fond as he seems, condemns his joys to death.

 Mine died with thee, PHILANDER! thy last sigh
Dissolved the charm; the disenchanted earth
Lost all her lustre: where her glitt'ring towers?
Her golden mountains where?—all darken'd down

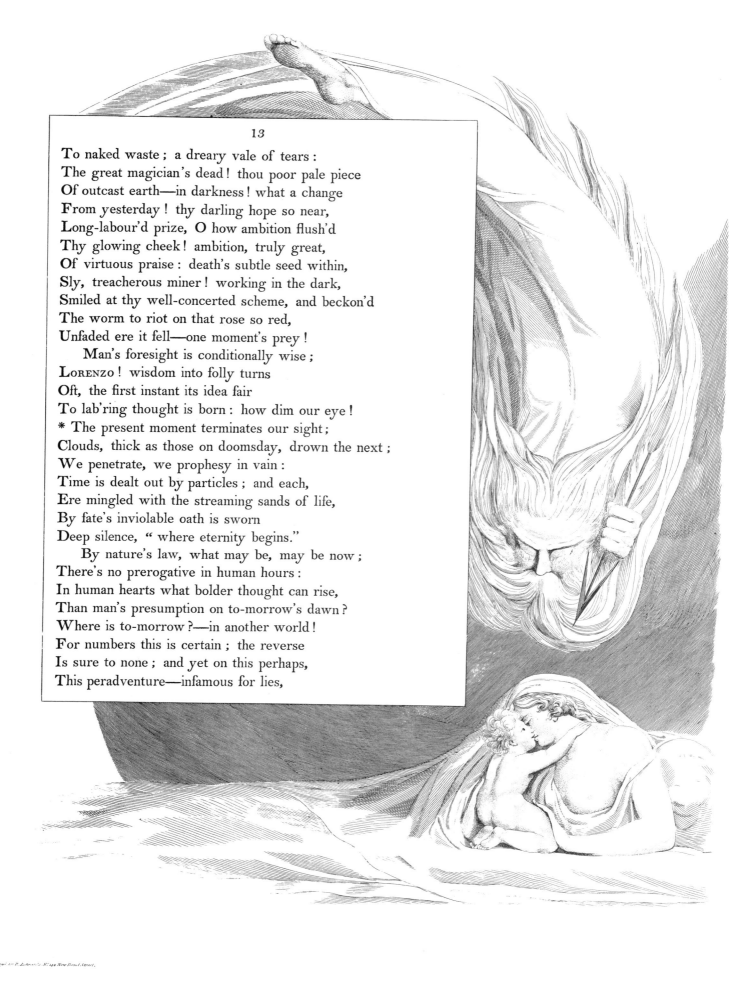

To naked waste; a dreary vale of tears:
The great magician's dead! thou poor pale piece
Of outcast earth—in darkness! what a change
From yesterday! thy darling hope so near,
Long-labour'd prize, O how ambition flush'd
Thy glowing cheek! ambition, truly great,
Of virtuous praise: death's subtle seed within,
Sly, treacherous miner! working in the dark,
Smiled at thy well-concerted scheme, and beckon'd
The worm to riot on that rose so red,
Unfaded ere it fell—one moment's prey!
 Man's foresight is conditionally wise;
LORENZO! wisdom into folly turns
Oft, the first instant its idea fair
To lab'ring thought is born: how dim our eye!
* The present moment terminates our sight;
Clouds, thick as those on doomsday, drown the next;
We penetrate, we prophesy in vain:
Time is dealt out by particles; and each,
Ere mingled with the streaming sands of life,
By fate's inviolable oath is sworn
Deep silence, " where eternity begins."
 By nature's law, what may be, may be now;
There's no prerogative in human hours:
In human hearts what bolder thought can rise,
Than man's presumption on to-morrow's dawn?
Where is to-morrow?—in another world!
For numbers this is certain; the reverse
Is sure to none; and yet on this perhaps,
This peradventure—infamous for lies,

Published 1 April by R. Edwards Nº 142 New Bond Street.

As on a rock of adamant we build
Our mountain hopes ; spin our eternal schemes,
As we the fatal sisters would outspin,
And, big with life's futurities, expire.
 Not even PHILANDER had bespoke his shroud,
Nor had he cause ; a warning was denied :
How many fall as sudden—not as safe !
As sudden, though for years admonish'd home.
Of human ills the last extreme beware,
Beware, LORENZO ! a slow-sudden death :
How dreadful that deliberate surprise !
Be wise to-day, 'tis madness to defer ;
Next day the fatal precedent will plead ;
Thus on, till wisdom is push'd out of life :
Procrastination is the thief of time ;
Year after year it steals, till all are fled ;
And to the mercies of a moment leaves
The vast concerns of an eternal scene :
If not so frequent, would not this be strange ?
That 'tis so frequent, this is stranger still.
 Of man's miraculous mistakes, this bears
The palm, " That all men are about to live"—
For ever on the brink of being born.
All pay themselves the compliment to think
They one day shall not drivel ; and their pride
On this reversion takes up ready praise,
At least their own, their future selves applauds :
How excellent that life they ne'er will lead !
Time lodged in their own hands is folly's vails ;
That lodged in fate's, to wisdom they consign ;

The thing they can't but purpose, they postpone:
'Tis not in folly, not to scorn a fool;
And scarce in human wisdom to do more:
All promise is poor dilatory man,
And that through every stage: when young, indeed,
In full content we sometimes nobly rest,
Unanxious for ourselves; and only wish,
As duteous sons, our fathers were more wise:
At thirty man suspects himself a fool;
Knows it at forty, and reforms his plan;
At fifty chides his infamous delay,
Pushes his prudent purpose to resolve;
In all the magnanimity of thought
Resolves, and re-resolves; then dies the same.

 And why? because he thinks himself immortal:
All men think all men mortal, but themselves;
Themselves;—when some alarming shock of fate
Strikes through their wounded hearts the sudden dread;
But their hearts wounded, like the wounded air,
Soon close; where pass'd the shaft no trace is found.
As from the wing no scar the sky retains;
The parted wave no furrow from the keel;
So dies in human hearts the thought of death:
Even with the tender tear which nature sheds
O'er those we love, we drop it in their grave.
Can I forget PHILANDER? that were strange:
O my full heart!—but should I give it vent,
* The longest night though longer far, would fail,
And the lark listen to my midnight song.

Pub.ᵈ June 27. 1796. by R. Edwards, Nᵒ 142. New Bond Street.

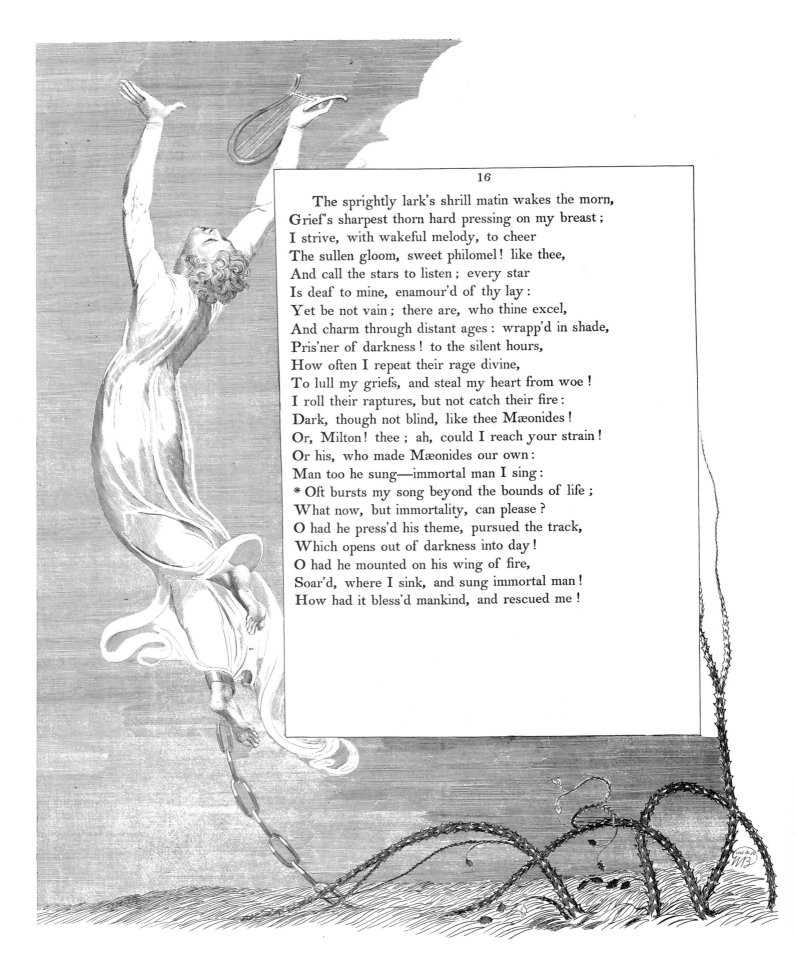

16

The sprightly lark's shrill matin wakes the morn,
Grief's sharpest thorn hard pressing on my breast;
I strive, with wakeful melody, to cheer
The sullen gloom, sweet philomel! like thee,
And call the stars to listen; every star
Is deaf to mine, enamour'd of thy lay:
Yet be not vain; there are, who thine excel,
And charm through distant ages: wrapp'd in shade,
Pris'ner of darkness! to the silent hours,
How often I repeat their rage divine,
To lull my griefs, and steal my heart from woe!
I roll their raptures, but not catch their fire:
Dark, though not blind, like thee Mæonides!
Or, Milton! thee; ah, could I reach your strain!
Or his, who made Mæonides our own:
Man too he sung—immortal man I sing:
* Oft bursts my song beyond the bounds of life;
What now, but immortality, can please?
O had he press'd his theme, pursued the track,
Which opens out of darkness into day!
O had he mounted on his wing of fire,
Soar'd, where I sink, and sung immortal man!
How had it bless'd mankind, and rescued me!

London Pub.d June.21, 1795. by R. Edwards, 142 New Bond Street.

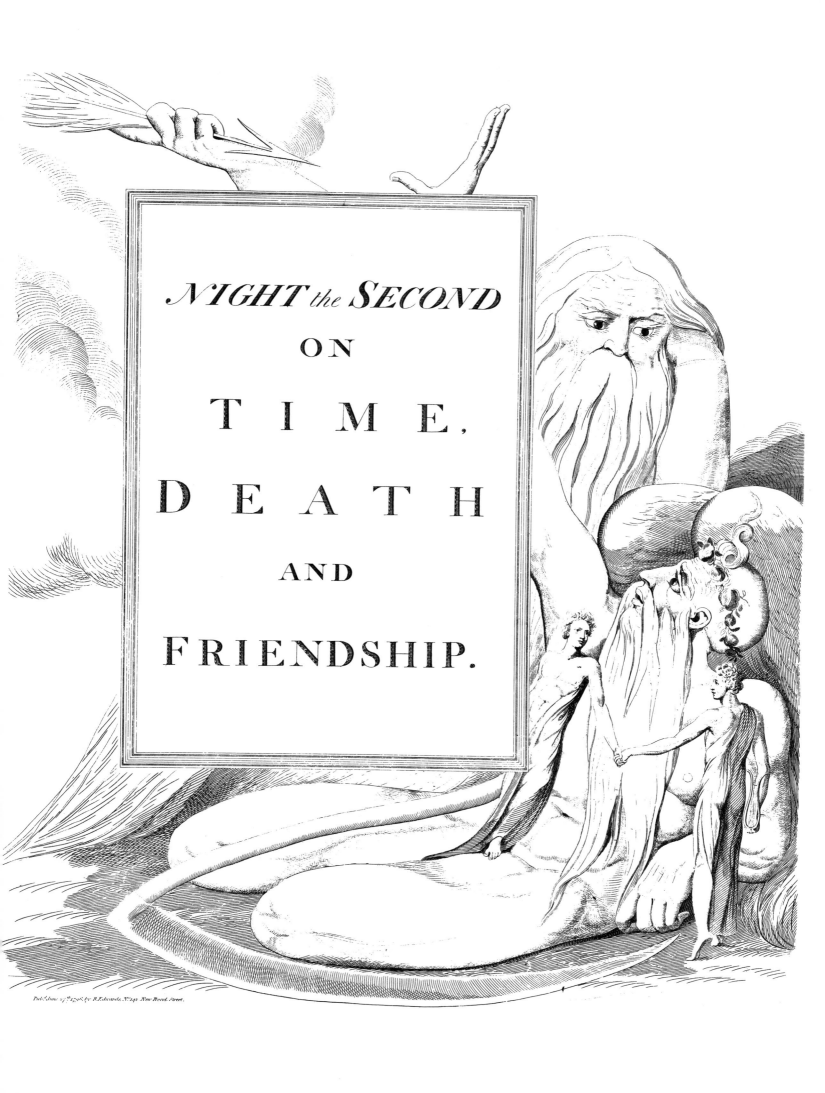

NIGHT the SECOND

ON

TIME,

DEATH

AND

FRIENDSHIP.

Pub.d June 27.th 1796, by R.Edwards, N.º 142 New Bond Street.

19

NIGHT THE SECOND.

" WHEN the cock crew, he wept"—smote by that eye
Which looks on me, on all ; that power, who bids
This midnight centinel, with clarion shrill,
* Emblem of that which shall awake the dead,
Rouse souls from slumber into thoughts of heaven :
Shall I too weep ? where then is fortitude ?
And, fortitude abandon'd, where is man ?
I know the terms on which he sees the light ;
He that is born, is listed ; life is war,
Eternal war with woe : who bears it best,
Deserves it least—on other themes I'll dwell.
LORENZO ! let me turn my thoughts on thee,
And thine, on themes may profit ; profit there,
Where most thy need—themes, too, the genuine growth
Of dear PHILANDER's dust : he, thus, though dead,
May still befriend.—What themes ? time's wondrous price,
Death, friendship, and PHILANDER's final scene.

Pub.ᵈ June. 27, 1796. by R.Edwards, Nᵒ 142 New Bond Street.

So could I touch these themes, as might obtain
Thine ear, nor leave thy heart quite disengaged,
The good deed would delight me ; half impress
On my dark cloud an iris ; and from grief
Call glory :—dost thou mourn PHILANDER's fate ?
* I know thou say'st it : says thy life the same ?
He mourns the dead, who lives as they desire.
Where is that thrift, that avarice of time,
O glorious avarice ! thought of death inspires,
As rumour'd robberies endear our gold ?
O time ! than gold more sacred ; more a load
Than lead, to fools ; and fools reputed wise :
What moment granted man without account ?
What years are squander'd, wisdom's debt unpaid !
Our wealth in days all due to that discharge.
Haste, haste, he lies in wait, he's at the door,
Insidious death ! should his strong hand arrest,
No composition sets the pris'ner free ;
Eternity's inexorable chain
Fast binds, and vengeance claims the full arrear.

How late I shudder'd on the brink ! how late
Life call'd for her last refuge in despair !
That time is mine, O MEAD ! to thee I owe ;
Fain would I pay thee with eternity :
But ill my genius answers my desire ;
My sickly song is mortal, past thy cure :
Accept the will—that dies not with my strain.

For what calls thy disease, LORENZO ? not
For esculapian, but for moral aid :
Thou think'st it folly to be wise too soon.

Youth is not rich in time; it may be, poor;
Part with it as with money—sparing; pay
No moment but in purchase of its worth;
And what its worth, ask death-beds; they can tell:
Part with it as with life—reluctant; big
With holy hope of nobler time to come;
Time higher aim'd, still nearer the great mark
Of men and angels—virtue more divine.

Is this our duty, wisdom, glory, gain?
These Heaven benign in vital union binds;
And sport we like the natives of the bough,
When vernal suns inspire? amusement reigns
Man's great demand; to trifle is to live:
And is it then a trifle too—to die?

Thou say'st I preach, LORENZO! 'tis confess'd:
What, if for once I preach thee quite awake?
Who wants amusement in the flame of battle?
Is it not treason to the soul immortal,
Her foes in arms, eternity the prize?
Will toys amuse, when med'cines cannot cure?
When spirits ebb, when life's enchanting scenes
Their lustre lose, and lessen in our sight,
As lands and cities with their glitt'ring spires,
To the poor shatter'd bark, by sudden storm
Thrown off to sea, and soon to perish there;
Will toys amuse?—No: thrones will then be toys,
And earth and skies seem dust upon the scale.

Redeem we time?—Its loss we dearly buy:
What pleads LORENZO for his high-prized sports?
He pleads time's numerous blanks; he loudly pleads

The straw-like trifles on life's common stream :
From whom those blanks and trifles, but from thee ?
No blank, no trifle nature made, or meant.
Virtue, or purposed virtue, still be thine ;
This cancels thy complaint at once, this leaves
In act no trifle, and no blank in time ;
This greatens, fills, immortalizes all ;
This, the blest art of turning all to gold ;
This, the good heart's prerogative to raise
A royal tribute from the poorest hours :
Immense revenue ! every moment pays.
If nothing more than purpose in thy power ;
Thy purpose firm, is equal to the deed :
Who does the best his circumstance allows,
Does well, acts nobly ;—angels could no more.
Our outward act, indeed, admits restraint :
'Tis not in things o'er thought to domineer ;
Guard well thy thought ; our thoughts are heard in heaven.
 On all-important time, through every age,
Though much, and warm, the wise have urged ; the man
Is yet unborn, who duly weighs an hour.
" I've lost a day"—the prince who nobly cried,
Had been an emperor without his crown—
Of Rome ? say rather, lord of human race ;
He spoke, as if deputed by mankind :
So should all speak ; so reason speaks in all :
From the soft whispers of that God in man,
Why fly to folly, why to frenzy fly,
For rescue from the blessings we possess ?
Time, the supreme !—Time is eternity ;

Pregnant with all eternity can give ;
Pregnant with all that makes archangels smile :
Who murders time, he crushes in the birth
A power ethereal, only not adored.
 Ah ! how unjust to nature and himself,
Is thoughtless, thankless, inconsistent man !
Like children babbling nonsense in their sports,
* We censure nature for a span too short ;
That span too short, we tax as tedious too ;
Torture invention, all expedients tire,
To lash the ling'ring moments into speed,
And whirl us, happy riddance ! from ourselves.
Art, brainless art ! our furious charioteer,
For nature's voice unstifled would recall,
Drives headlong tow'rds the precipice of death—
Death, most our dread ; death thus more dreadful made
O what a riddle of absurdity !
Leisure is pain ; take off our chariot-wheels,
How heavily we drag the load of life !
Blest leisure is our curse ; like that of Cain,
It makes us wander ; wander earth around
To fly that tyrant, thought. As Atlas groan'd
The world beneath, we groan beneath an hour :
We cry for mercy to the next amusement ;
The next amusement mortgages our fields—
Slight inconvenience ! prisons hardly frown—
From hateful time if prisons set us free ;
Yet when death kindly tenders us relief,
We call him cruel ; years to moments shrink,
Ages to years : the telescope is turn'd,

Pub.d June 27.d 1796 by R.Edwards N.o 142 New Bond St.

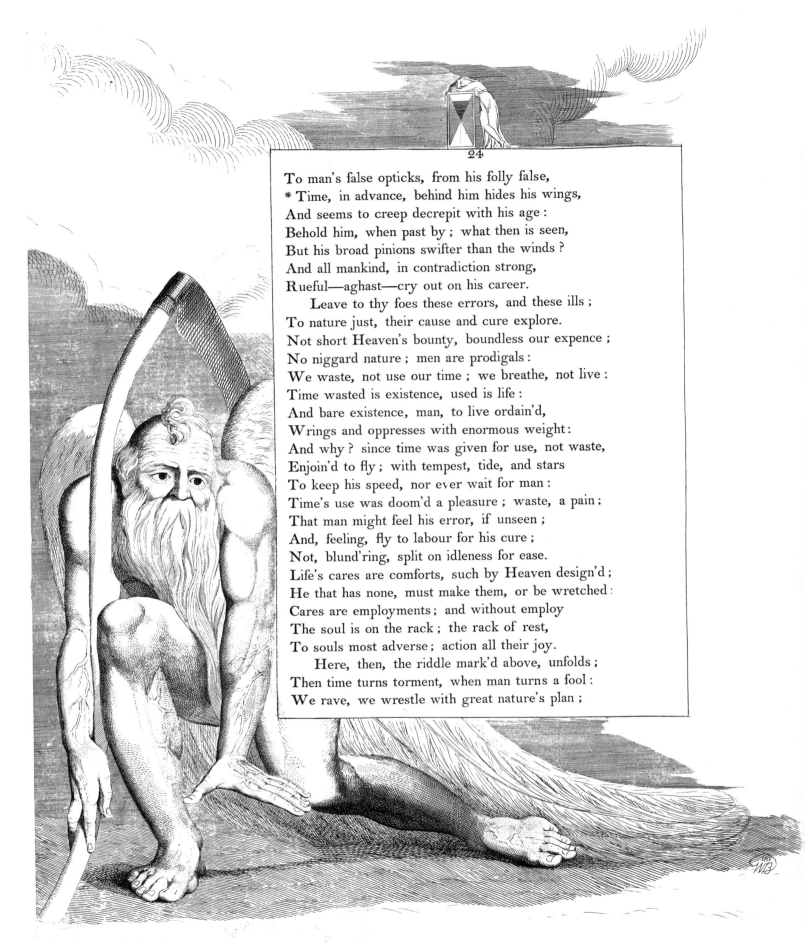

To man's false opticks, from his folly false,
* Time, in advance, behind him hides his wings,
And seems to creep decrepit with his age :
Behold him, when past by ; what then is seen,
But his broad pinions swifter than the winds ?
And all mankind, in contradiction strong,
Rueful—aghast—cry out on his career.

Leave to thy foes these errors, and these ills ;
To nature just, their cause and cure explore.
Not short Heaven's bounty, boundless our expence ;
No niggard nature ; men are prodigals :
We waste, not use our time ; we breathe, not live :
Time wasted is existence, used is life :
And bare existence, man, to live ordain'd,
Wrings and oppresses with enormous weight :
And why ? since time was given for use, not waste,
Enjoin'd to fly ; with tempest, tide, and stars
To keep his speed, nor ever wait for man :
Time's use was doom'd a pleasure ; waste, a pain :
That man might feel his error, if unseen ;
And, feeling, fly to labour for his cure ;
Not, blund'ring, split on idleness for ease.
Life's cares are comforts, such by Heaven design'd ;
He that has none, must make them, or be wretched :
Cares are employments ; and without employ
The soul is on the rack ; the rack of rest,
To souls most adverse ; action all their joy.

Here, then, the riddle mark'd above, unfolds ;
Then time turns torment, when man turns a fool :
We rave, we wrestle with great nature's plan ;

June 27 1796 by R. Edwards N°142 New Bond Street.

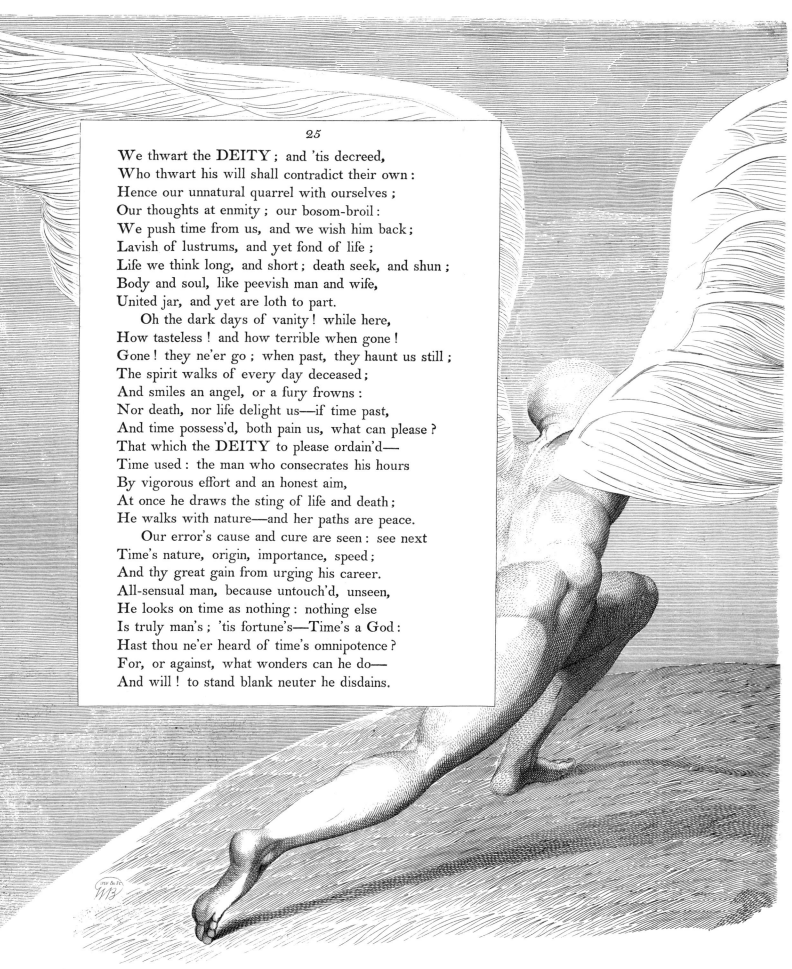

We thwart the DEITY; and 'tis decreed,
Who thwart his will shall contradict their own:
Hence our unnatural quarrel with ourselves;
Our thoughts at enmity; our bosom-broil:
We push time from us, and we wish him back;
Lavish of lustrums, and yet fond of life;
Life we think long, and short; death seek, and shun;
Body and soul, like peevish man and wife,
United jar, and yet are loth to part.

Oh the dark days of vanity! while here,
How tasteless! and how terrible when gone!
Gone! they ne'er go; when past, they haunt us still;
The spirit walks of every day deceased;
And smiles an angel, or a fury frowns:
Nor death, nor life delight us—if time past,
And time possess'd, both pain us, what can please?
That which the DEITY to please ordain'd—
Time used: the man who consecrates his hours
By vigorous effort and an honest aim,
At once he draws the sting of life and death;
He walks with nature—and her paths are peace.

Our error's cause and cure are seen: see next
Time's nature, origin, importance, speed;
And thy great gain from urging his career.
All-sensual man, because untouch'd, unseen,
He looks on time as nothing: nothing else
Is truly man's; 'tis fortune's—Time's a God:
Hast thou ne'er heard of time's omnipotence?
For, or against, what wonders can he do—
And will! to stand blank neuter he disdains.

Pub.ᵈ June 27. 1796, by R.Edwards, N°.42 New Bond Street

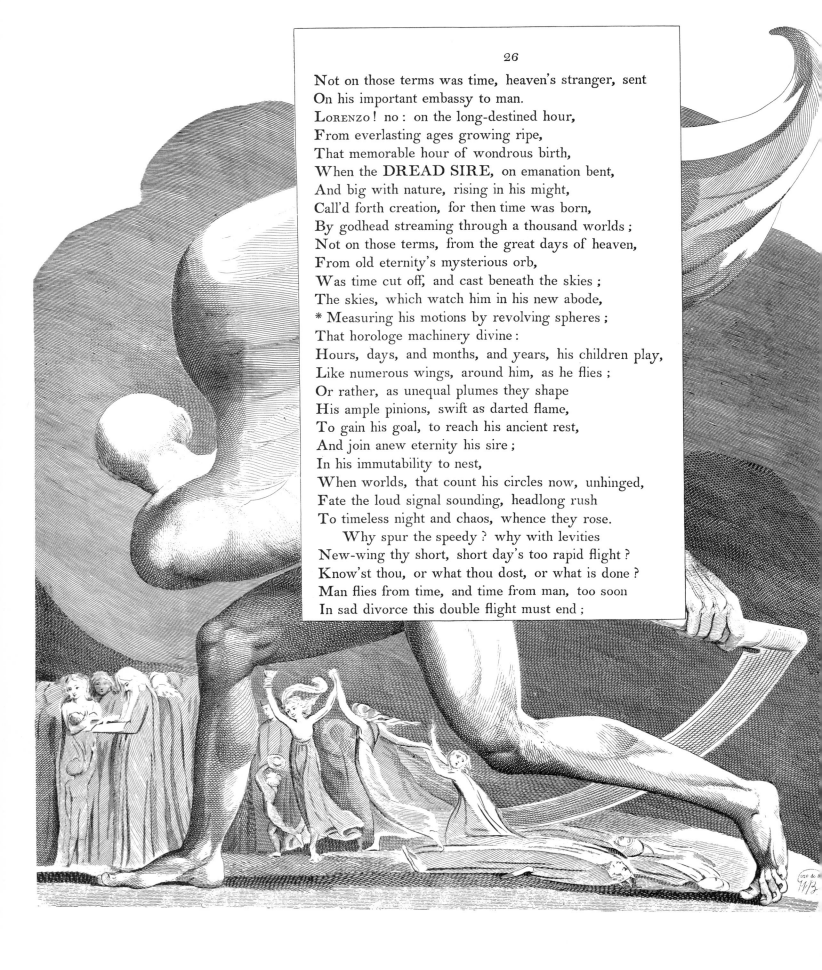

Not on those terms was time, heaven's stranger, sent
On his important embassy to man.
LORENZO! no : on the long-destined hour,
From everlasting ages growing ripe,
That memorable hour of wondrous birth,
When the DREAD SIRE, on emanation bent,
And big with nature, rising in his might,
Call'd forth creation, for then time was born,
By godhead streaming through a thousand worlds ;
Not on those terms, from the great days of heaven,
From old eternity's mysterious orb,
Was time cut off, and cast beneath the skies ;
The skies, which watch him in his new abode,
* Measuring his motions by revolving spheres ;
That horologe machinery divine :
Hours, days, and months, and years, his children play,
Like numerous wings, around him, as he flies ;
Or rather, as unequal plumes they shape
His ample pinions, swift as darted flame,
To gain his goal, to reach his ancient rest,
And join anew eternity his sire ;
In his immutability to nest,
When worlds, that count his circles now, unhinged,
Fate the loud signal sounding, headlong rush
To timeless night and chaos, whence they rose.

 Why spur the speedy ? why with levities
New-wing thy short, short day's too rapid flight ?
Know'st thou, or what thou dost, or what is done ?
Man flies from time, and time from man, too soon
In sad divorce this double flight must end ;

And then, where are we ? where, LORENZO, then
Thy sports—thy pomps ?—I grant thee, in a state
Not unambitious ; in the ruffled shroud,
Thy parian tomb's triumphant arch beneath :
Has death his fopperies ? then well may life
Put on her plume, and in her rainbow shine.

 Ye well-array'd ! ye lilies of our land !
Ye lilies male ! who neither toil, nor spin,
As sister lilies might ;—if not so wise
As Solomon, more sumptuous to the sight !
Ye delicate ! who nothing can support,
Yourselves most insupportable ! for whom
The winter rose must blow, the sun put on
A brighter beam in Leo, silky-soft
Favonius breathe still softer, or be chid ;
And other worlds send odours, sauce, and song,
And robes, and notions framed in foreign looms !
O ye LORENZOS of our age ! who deem
One moment unamused, a misery
Not made for feeble man ; who call aloud
For every bauble, drivell'd o'er by sense,
For rattles and conceits of every cast,
For change of follies and relays of joy,
To drag your patience through the tedious length
Of a short winter's day—say—sages ; say
Wit's oracles ; say—dreamers of gay dreams ;
How will you weather an eternal night,
Where such expedients fail ?

 * O treacherous conscience ! while she seems to sleep
On rose and myrtle, lull'd with syren song ;

Pub.d June 27 1796. by R. Edwards, N.o 142, New Bond Street.

While she seems, nodding o'er her charge, to drop
On headlong appetite the slacken'd rein,
And give us up to licence, unrecall'd,
Unmark'd ;—see, from behind her secret stand,
The sly informer minutes every fault,
And her dread diary with horror fills :
Not the gross act alone employs her pen ;
She reconnoitres fancy's airy band,
A watchful foe ! the formidable spy,
List'ning, o'erhears the whispers of our camp ;
Our dawning purposes of heart explores,
And steals our embryos of iniquity.
As all-rapacious usurers conceal
Their doomsday-book from all-consuming heirs,
Thus, with indulgence most severe she treats
Us spendthrifts of inestimable time ;
Unnoted, notes each moment misapplied ;
In leaves more durable than leaves of brass,
Writes our whole history ; which death shall read
In every pale delinquent's private ear,
And judgment publish—publish to more worlds
Than this ; and endless age in groans resound.
Lorenzo, such that sleeper in thy breast !
Such is her slumber ; and her vengeance such
For slighted counsel ;—such thy future peace !
And think'st thou still thou canst be wise too soon ?
　　But why on time so lavish is my song ?
On this great theme kind nature keeps a school,
To teach her sons herself : each night we die,
Each morn are born anew : each day—a life !

And shall we kill each day ? If trifling kills,
Sure vice must butcher : O what heaps of slain
Cry out for vengeance on us ! time destroy'd
Is suicide, where more than blood is spilt :
Time flies, death urges, knells call, heaven invites,
Hell threatens : all exerts ; in effort, all
More than creation labours !—labours more ?
And is there in creation, what, amidst
This tumult universal, wing'd dispatch,
And ardent energy, supinely yawns ?—
Man sleeps—and man alone ; and man, whose fate—
Fate irreversible, entire, extreme,
Endless, hair-hung, breeze-shaken, o'er the gulph
A moment trembles—drops ! and man, for whom
All else is in alarm ; man, the sole cause
Of this surrounding storm ! and yet he sleeps,
As the storm rock'd to rest.——Throw years away—
Throw empires—and be blameless ?—moments seize ;
Heaven 's on their wing : a moment we may wish,
When worlds want wealth to buy :—bid day stand still,
Bid him drive back his car, and reimport
The period past, regive the given hour.
Lorenzo, more than miracles we want ;
Lorenzo—O for yesterdays to come !
　　Such is the language of the man awake ;
His ardour such, for what oppresses thee :
And is his ardour vain, Lorenzo ? no,
That more than miracle the gods indulge ;
To-day is yesterday return'd ; return'd
Full-power'd to cancel, expiate, raise, adorn,

And reinstate us on the rock of peace.
Let it not share its predecessor's fate ;
Nor, like its elder sisters, die a fool :
Shall it evaporate in fume—fly off
Fuliginous, and stain us deeper still ?
Shall we be poorer for the plenty pour'd ?
More wretched for the clemencies of heaven ?

 Where shall I find him ? angels ! tell me where—
You know him : he is near you—point him out :
Shall I see glories beaming from his brow ?
Or trace his footsteps by the rising flowers ?
Your golden wings, now hov'ring o'er him, shed
Protection ; now, are waving in applause
To that blest son of foresight—lord of fate—
That aweful independent on to-morrow !
Whose work is done ; who triumphs in the past ;
Whose yesterdays look backward with a smile,
Nor, like the Parthian, wound him as they fly ;
That common, but opprobrious lot ! past hours,
If not by guilt, yet wound us by their flight,
If folly bounds our prospect by the grave,
All feeling of futurity benumb'd ;
All god-like passion for eternals quench'd ;
All relish of realities expired ;
Renounced all correspondence with the skies ;
Our freedom chain'd ; quite wingless our desire :
In sense dark-prison'd all that ought to soar ;
Prone to the centre ; crawling in the dust ;
Dismounted every great and glorious aim ;
Embruted every faculty divine ;

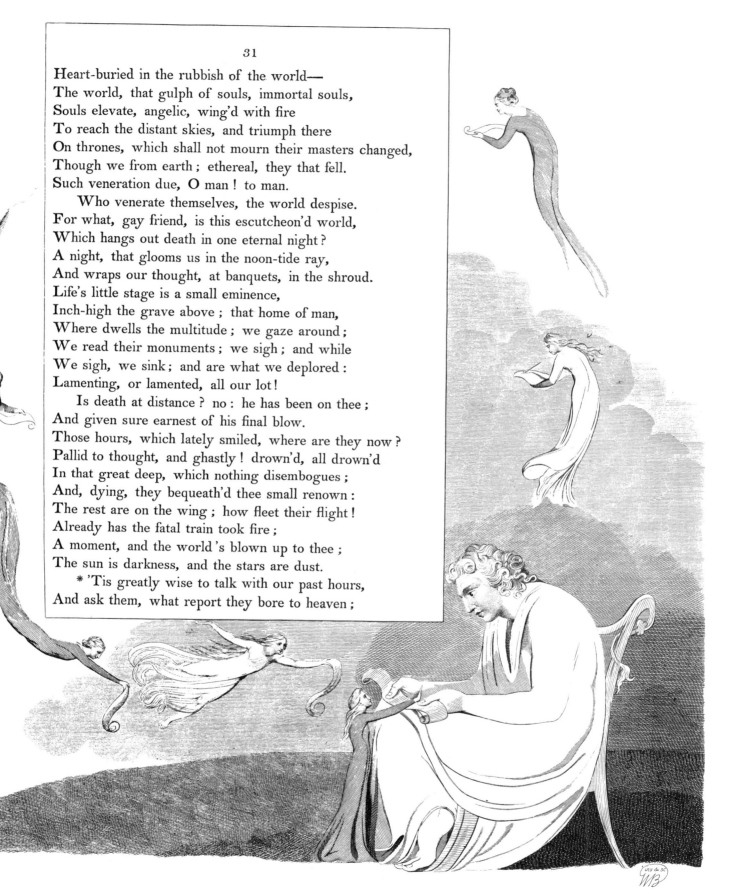

Heart-buried in the rubbish of the world—
The world, that gulph of souls, immortal souls,
Souls elevate, angelic, wing'd with fire
To reach the distant skies, and triumph there
On thrones, which shall not mourn their masters changed,
Though we from earth ; ethereal, they that fell.
Such veneration due, O man ! to man.
 Who venerate themselves, the world despise.
For what, gay friend, is this escutcheon'd world,
Which hangs out death in one eternal night ?
A night, that glooms us in the noon-tide ray,
And wraps our thought, at banquets, in the shroud.
Life's little stage is a small eminence,
Inch-high the grave above ; that home of man,
Where dwells the multitude ; we gaze around ;
We read their monuments ; we sigh ; and while
We sigh, we sink ; and are what we deplored :
Lamenting, or lamented, all our lot !
 Is death at distance ? no : he has been on thee ;
And given sure earnest of his final blow.
Those hours, which lately smiled, where are they now ?
Pallid to thought, and ghastly ! drown'd, all drown'd
In that great deep, which nothing disembogues ;
And, dying, they bequeath'd thee small renown :
The rest are on the wing ; how fleet their flight !
Already has the fatal train took fire ;
A moment, and the world's blown up to thee ;
The sun is darkness, and the stars are dust.
 * 'Tis greatly wise to talk with our past hours,
And ask them, what report they bore to heaven ;

And how they might have borne more welcome news:
Their answers form what men experience call;
If wisdom's friend, her best; if not, worst foe.
O reconcile them! kind experience cries,
" There 's nothing here, but what as nothing weighs;
" The more our joy, the more we know it vain;
" And by success are tutor'd to despair."
Nor is it only thus, but must be so:
Who knows not this, though gray, is still a child:
Loose then from earth the grasp of fond desire,
Weigh anchor, and some happier clime explore.

 Art thou so moor'd thou canst not disengage,
Nor give thy thoughts a ply to future scenes ?
Since, by life's passing breath, blown up from earth,
Light, as the summer's dust, we take in air
A moment's giddy flight, and fall again;
Join the dull mass, increase the trodden soil,
And sleep 'till earth herself shall be no more;
Since then, as emmets, their small world o'erthrown,
We, sore amazed, from out earth's ruins crawl,
And rise to fate extreme of foul or fair,
As man's own choice, controller of the skies !
As man's despotic will, perhaps one hour
O how omnipotent is time ! decrees;
Should not each warning give a strong alarm—
Warning, far less than that of bosom torn
From bosom, bleeding o'er the sacred dead ?
Should not each dial strike us as we pass,
Portentous, as the written wall which struck,
O'er midnight bowls, the proud Assyrian pale,

Erewhile high-flush'd with insolence and wine?
* Like that, the dial speaks; and points to thee,
LORENZO! loth to break thy banquet up.
" O man, thy kingdom is departing from thee;
" And, while it lasts, is emptier than my shade."
Its silent language such; nor need'st thou call
Thy magi, to decypher what it means:
Know, like the Median, fate is in thy walls:
Dost ask, how? whence? Belshazzar-like, amazed?
Man's make encloses the sure seeds of death;
Life feeds the murderer: ingrate! he thrives
On her own meal, and then his nurse devours.
 But here, LORENZO, the delusion lies;
That solar shadow, as it measures life,
It life resembles too: life speeds away
From point to point, though seeming to stand still:
The cunning fugitive is swift by stealth,
Too subtle is the movement to be seen;
Yet soon man's hour is up, and we are gone.
Warnings point out our danger; gnomons, time:
As these are useless when the sun is set;
So those, but when more glorious reason shines:
Reason should judge in all; in reason's eye,
That sedentary shadow travels hard:
But such our gravitation to the wrong,
So prone our hearts to whisper what we wish,
'Tis later with the wise, than he's aware;
A Wilmington goes slower than the sun;
And all mankind mistake their time of day;
Even age itself: fresh hopes are hourly sown

In furrow'd brows : so gentle life's descent,
We shut our eyes, and think it is a plain.
We take fair days in winter for the spring ;
And turn our blessings into bane : since oft
Man must compute that age he cannot feel,
He scarce believes he 's older for his years :
Thus, at life's latest eve, we keep in store
One disappointment sure, to crown the rest—
The disappointment of a promised hour.

On this, or similar, PHILANDER ! thou,
Whose mind was moral, as the preacher's tongue ;
And strong to wield all science, worth the name ;
How often we talk'd down the summer's sun,
And cool'd our passions by the breezy stream !
How often thaw'd and shorten'd winter's eve,
By conflict kind, that struck out latent truth,
Best found, so sought ; to the recluse more coy !
Thoughts disentangle passing o'er the lip ;
Clean runs the thread ; if not, 'tis thrown away,
Or kept to tie up nonsense for a song—
Song, fashionably fruitless ! such as stains
The fancy, and unhallow'd passion fires ;
Chiming her saints to Cytherea's fane.

Know'st thou, LORENZO ! what a friend contains ?
As bees mix'd nectar draw from fragrant flowers,
So men from friendship, wisdom and delight ;
Twins tied by nature ; if they part, they die.
Hast thou no friend to set thy mind abroach ?
Good sense will stagnate : thoughts shut up, want air,
And spoil, like bales unopen'd to the sun.

Had thought been all, sweet speech had been denied;
Speech, thought's canal! speech, thought's criterion too!
Thought in the mine may come forth gold or dross;
When coin'd in words, we know its real worth:
If sterling, store it for thy future use;
'Twill buy thee benefit, perhaps renown:
Thought too, deliver'd, is the more possess'd;
* Teaching, we learn; and giving, we retain
The births of intellect; when dumb, forgot.
Speech ventilates our intellectual fire;
Speech burnishes our mental magazine;
Brightens for ornament, and whets for use.
What numbers, sheath'd in erudition, lie
Plunged to the hilts in venerable tomes,
And rusted; who might have borne an edge,
And play'd a sprightly beam, if born to speech!
If born blest heirs to half their mother's tongue!
'Tis thought's exchange, which, like th' alternate push
Of waves conflicting, breaks the learned scum,
And defecates the student's standing pool.
 In contemplation is his proud resource?
'Tis poor as proud: by converse unsustain'd
Rude thought runs wild in contemplation's field:
Converse, the menage, breaks it to the bit
Of due restraint; and emulation's spur
Gives graceful energy, by rivals awed:
'Tis converse qualifies for solitude,
As exercise for salutary rest:
By that untutor'd, contemplation raves;
And nature's fool, by wisdom's is outdone.

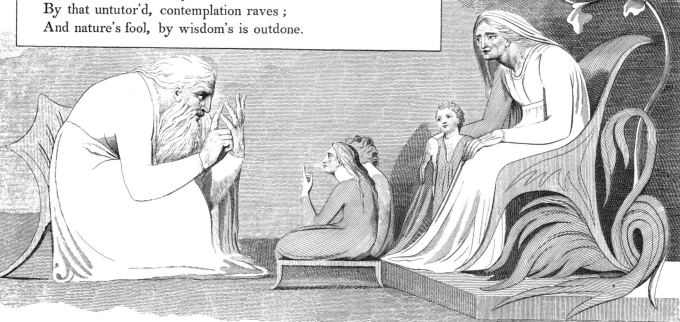

Wisdom, though richer than Peruvian mines,
And sweeter than the sweet ambrosial hive,
What is she but the means of happiness ?
That unobtain'd, than folly more a fool ;
A melancholy fool, without her bells.
Friendship, the means of wisdom, richly gives
The precious end, which makes our wisdom wise.
Nature, in zeal for human amity,
Denies, or damps an undivided joy :
Joy is an import—joy is an exchange—
Joy flies monopolists ; it calls for two :
Rich fruit ! heaven-planted ! never pluck'd by one.
Needful auxiliars are our friends, to give
To social man true relish of himself.
Full on ourselves descending in a line,
Pleasure's bright beam is feeble in delight :
Delight intense is taken by rebound ;
Reverberated pleasures fire the breast.

 Celestial happiness, whene'er she stoops
To visit earth, one shrine the goddess finds,
And one alone, to make her sweet amends
For absent heaven—the bosom of a friend ;
Where heart meets heart, reciprocally soft,
Each other's pillow to repose divine.
Beware the counterfeit : in passion's flame
Hearts melt ; but melt like ice, soon harder froze :
True love strikes root in reason, passion's foe :
Virtue alone entenders us for life—
I wrong her much—entenders us for ever :
Of friendship's fairest fruits, the fruit most fair

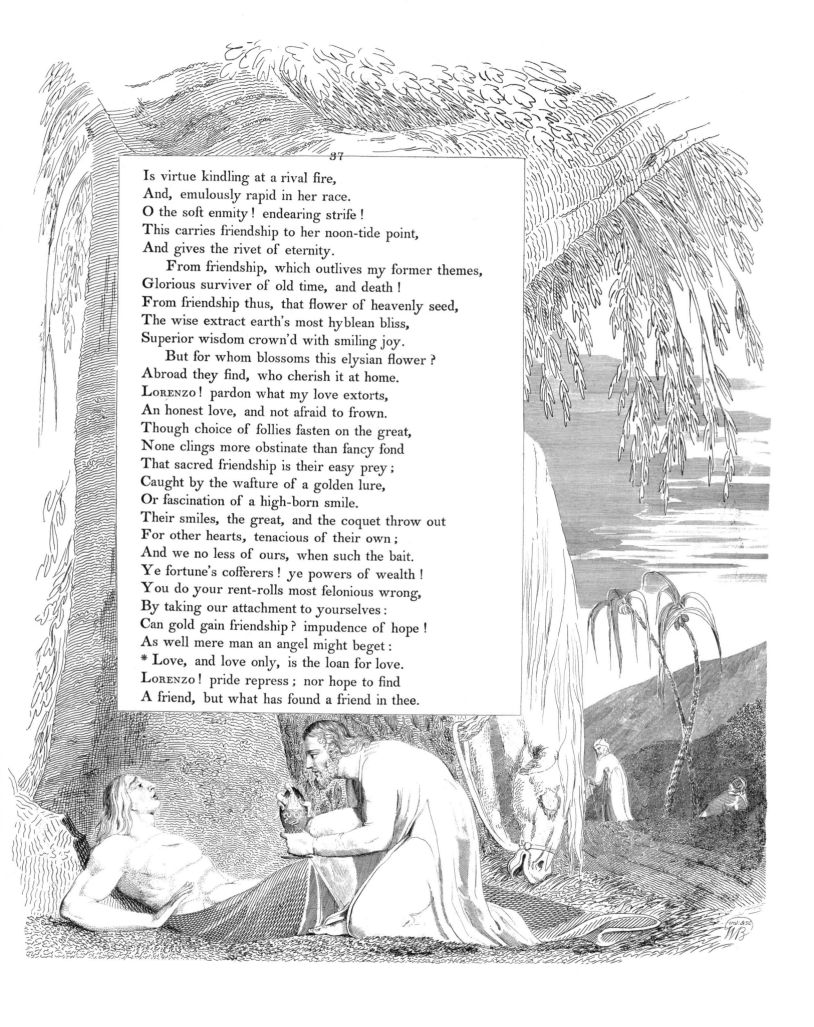

Is virtue kindling at a rival fire,
And, emulously rapid in her race.
O the soft enmity! endearing strife!
This carries friendship to her noon-tide point,
And gives the rivet of eternity.

 From friendship, which outlives my former themes,
Glorious surviver of old time, and death!
From friendship thus, that flower of heavenly seed,
The wise extract earth's most hyblean bliss,
Superior wisdom crown'd with smiling joy.

 But for whom blossoms this elysian flower?
Abroad they find, who cherish it at home.
Lorenzo! pardon what my love extorts,
An honest love, and not afraid to frown.
Though choice of follies fasten on the great,
None clings more obstinate than fancy fond
That sacred friendship is their easy prey;
Caught by the wafture of a golden lure,
Or fascination of a high-born smile.
Their smiles, the great, and the coquet throw out
For other hearts, tenacious of their own;
And we no less of ours, when such the bait.
Ye fortune's cofferers! ye powers of wealth!
You do your rent-rolls most felonious wrong,
By taking our attachment to yourselves:
Can gold gain friendship? impudence of hope!
As well mere man an angel might beget:
* Love, and love only, is the loan for love.
Lorenzo! pride repress; nor hope to find
A friend, but what has found a friend in thee.

All like the purchase—few the price will pay ;
And this makes friends such miracles below.

　　What if, since daring on so nice a theme,
I shew thee friendship delicate as dear,
Of tender violations apt to die ?
Reserve will wound it, and distrust destroy :
Deliberate on all things with thy friend :
But since friends grow not thick on every bough,
Nor every friend unrotten at the core,
First on thy friend deliberate with thyself ;
Pause, ponder, sift ; not eager in the choice,
Nor jealous of the chosen, fixing fix :
Judge before friendship, then confide till death :
Well for thy friend ; but nobler far for thee ;
How gallant danger for earth's highest prize !
A friend is worth all hazard we can run :
" Poor is the friendless master of a world ;
" A world in purchase for a friend is gain."

　　So sung he, angels hear that angel sing !
Angels from friendship gather half their joy ;
So sung PHILANDER, as his friend went round
In the rich ichor, in the generous blood
Of Bacchus, purple god of joyous wit,
A brow solute, and ever-laughing eye :
He drank long health, and virtue to his friend ;
His friend, who warm'd him more, who more inspired.
Friendship's the wine of life ; but friendship new,
Not such was his, is neither strong nor pure.
O ! for the bright complexion, cordial warmth,
And elevating spirit of a friend,

For twenty summers ripening by my side ;
All feculence of falsehood long thrown down—
All social virtues rising in his soul—
As crystal clear, and smiling as they rise !
Here nectar flows ; it sparkles in our sight ;
Rich to the taste, and genuine from the heart :
High-flavour'd bliss for gods ! on earth how rare !
On earth how lost !—PHILANDER is no more.
 Think'st thou the theme intoxicates my song ?
And I too warm ?—too warm I cannot be.
I loved him much ; but now I love him more.
Like birds whose beauties languish, half conceal'd,
Till, mounted on the wing, their glossy plumes
Expanded shine with azure, green, and gold ;
How blessings brighten as they take their flight !
His flight PHILANDER took—his upward flight,
If ever soul ascended : had he dropt,
That eagle genius ! O had he let fall
One feather as he flew ! I then had wrote
What friends might flatter ; prudent foes forbear ;
Rivals scarce damn ; and Zoilus reprieve :
Yet what I can, I must : it were profane
To quench a glory lighted at the skies,
And cast in shadows his illustrious close.
Strange ! the theme most affecting, most sublime,
Momentous most to man, should sleep unsung !
And yet it sleeps by genius unawaked
Painim or christian, to the blush of wit.
Man's highest triumph ! man's profoundest fall !
The death-bed of the just—is yet undrawn

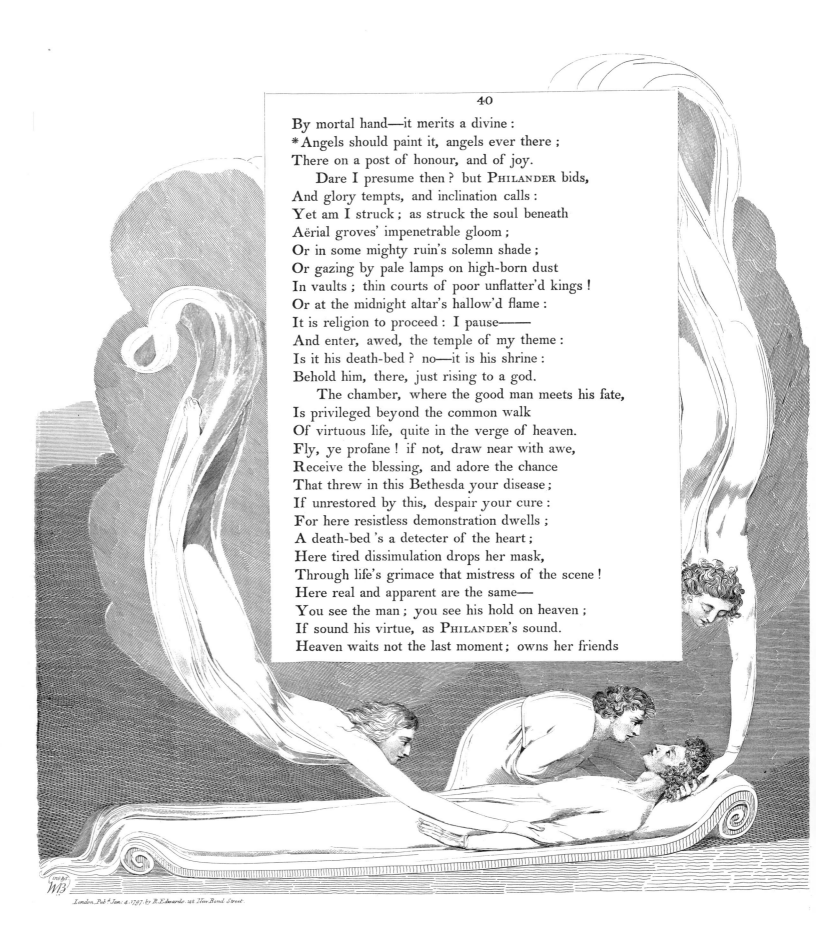

By mortal hand——it merits a divine :
*Angels should paint it, angels ever there ;
There on a post of honour, and of joy.
 Dare I presume then ? but PHILANDER bids,
And glory tempts, and inclination calls :
Yet am I struck ; as struck the soul beneath
Aërial groves' impenetrable gloom ;
Or in some mighty ruin's solemn shade ;
Or gazing by pale lamps on high-born dust
In vaults ; thin courts of poor unflatter'd kings !
Or at the midnight altar's hallow'd flame :
It is religion to proceed : I pause——
And enter, awed, the temple of my theme :
Is it his death-bed ? no——it is his shrine :
Behold him, there, just rising to a god.
 The chamber, where the good man meets his fate,
Is privileged beyond the common walk
Of virtuous life, quite in the verge of heaven.
Fly, ye profane ! if not, draw near with awe,
Receive the blessing, and adore the chance
That threw in this Bethesda your disease ;
If unrestored by this, despair your cure :
For here resistless demonstration dwells ;
A death-bed 's a detecter of the heart ;
Here tired dissimulation drops her mask,
Through life's grimace that mistress of the scene !
Here real and apparent are the same——
You see the man ; you see his hold on heaven ;
If sound his virtue, as PHILANDER's sound.
Heaven waits not the last moment ; owns her friends

London, Pub.ᵈ Jan: 4.1797. by R. Edwards, 142 New Bond Street.

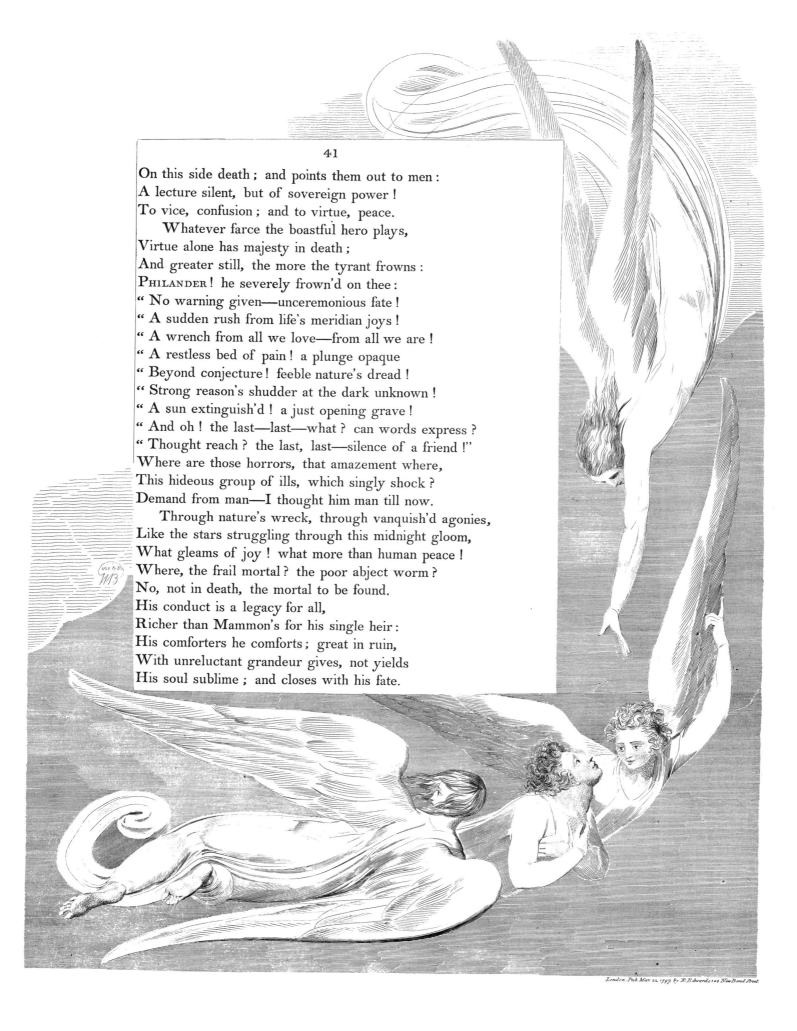

On this side death; and points them out to men:
A lecture silent, but of sovereign power!
To vice, confusion; and to virtue, peace.
 Whatever farce the boastful hero plays,
Virtue alone has majesty in death;
And greater still, the more the tyrant frowns:
PHILANDER! he severely frown'd on thee:
" No warning given—unceremonious fate!
" A sudden rush from life's meridian joys!
" A wrench from all we love—from all we are!
" A restless bed of pain! a plunge opaque
" Beyond conjecture! feeble nature's dread!
" Strong reason's shudder at the dark unknown!
" A sun extinguish'd! a just opening grave!
" And oh! the last—last—what? can words express?
" Thought reach? the last, last—silence of a friend!"
Where are those horrors, that amazement where,
This hideous group of ills, which singly shock?
Demand from man—I thought him man till now.
 Through nature's wreck, through vanquish'd agonies,
Like the stars struggling through this midnight gloom,
What gleams of joy! what more than human peace!
Where, the frail mortal? the poor abject worm?
No, not in death, the mortal to be found.
His conduct is a legacy for all,
Richer than Mammon's for his single heir:
His comforters he comforts; great in ruin,
With unreluctant grandeur gives, not yields
His soul sublime; and closes with his fate.

London, Pub. Mar. 22. 1797 by R. Edwards, 142 New Bond Street.

How our hearts burnt within us at the scene!
Whence this brave bound o'er limits fix'd to man?
His **GOD** sustains him in his final hour—
His final hour brings glory to his **GOD**!
Man's glory **HEAVEN** vouchsafes to call her own.
We gaze; we weep—mix'd tears of grief and joy!
Amazement strikes; devotion bursts to flame;
Christians adore—and infidels believe.

As some tall tower, or lofty mountain's brow
Detains the sun, illustrious from its height;
While rising vapours and descending shades
With damps and darkness drown the spacious vale;
Undamp'd by doubt, undarken'd by despair
PHILANDER, thus, augustly rears his head
At that black hour, which general horror sheds
On the low level of the inglorious throng:
Sweet peace, and heavenly hope, and humble joy
Divinely beam on his exalted soul,
Destruction gild, and crown him for the skies,
With incommunicable lustre bright.

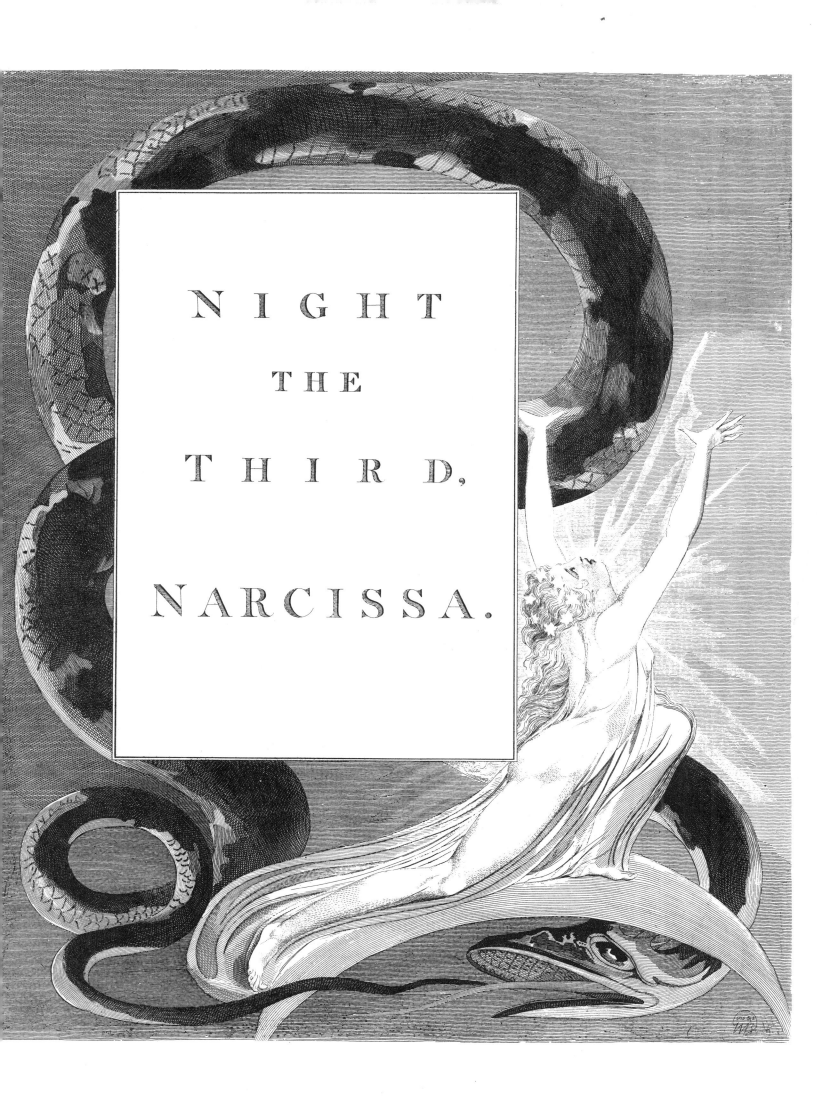

NIGHT

THE

THIRD,

NARCISSA.

NIGHT THE THIRD.

FROM dreams where thought in fancy's maze runs mad,
To reason, that heaven-lighted lamp in man,
Once more I wake ; and at the destined hour,
Punctual as lovers to the moment sworn,
I keep my assignation with my woe.
 O lost to virtue, lost to manly thought,
Lost to the noble sallies of the soul,
Who think it solitude to be alone !
Communion sweet ! communion large and high !
Our reason, guardian angel, and our God !
Then nearest these, when others most remote ;
And all, ere long shall be remote, but these.
How dreadful then to meet them all alone,
A stranger ! unacknowledged ! unapproved !
Now woo them, wed them, bind them to thy breast ;
To win thy wish creation has no more ;

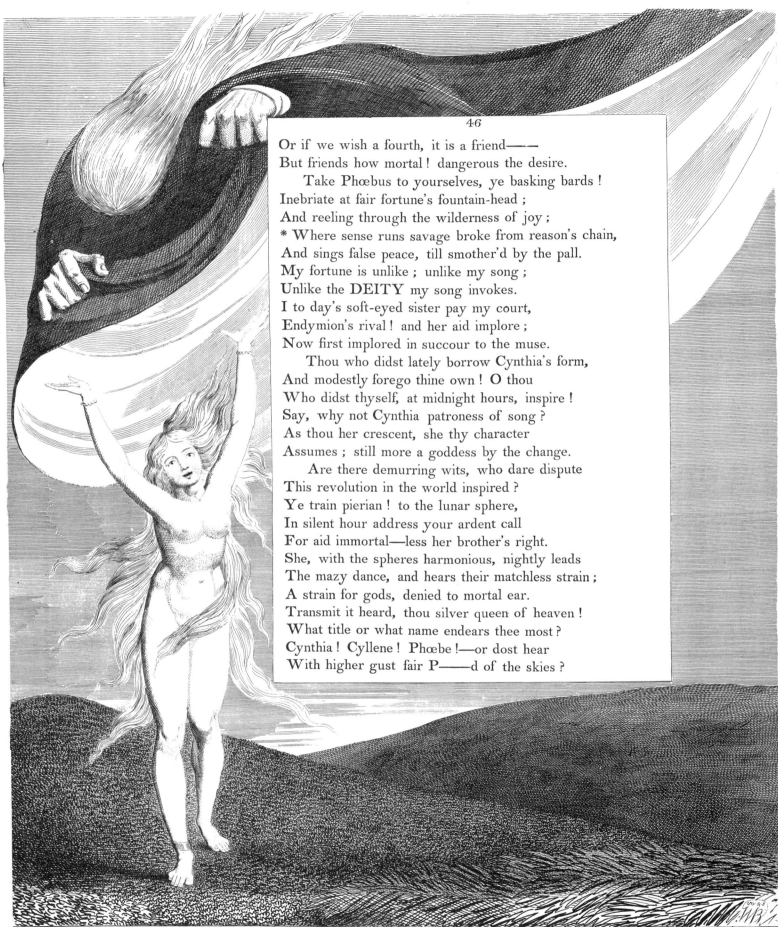

Or if we wish a fourth, it is a friend——
But friends how mortal! dangerous the desire.
 Take Phœbus to yourselves, ye basking bards!
Inebriate at fair fortune's fountain-head;
And reeling through the wilderness of joy;
* Where sense runs savage broke from reason's chain,
And sings false peace, till smother'd by the pall.
My fortune is unlike; unlike my song;
Unlike the DEITY my song invokes.
I to day's soft-eyed sister pay my court,
Endymion's rival! and her aid implore;
Now first implored in succour to the muse.
 Thou who didst lately borrow Cynthia's form,
And modestly forego thine own! O thou
Who didst thyself, at midnight hours, inspire!
Say, why not Cynthia patroness of song?
As thou her crescent, she thy character
Assumes; still more a goddess by the change.
 Are there demurring wits, who dare dispute
This revolution in the world inspired?
Ye train pierian! to the lunar sphere,
In silent hour address your ardent call
For aid immortal—less her brother's right.
She, with the spheres harmonious, nightly leads
The mazy dance, and hears their matchless strain;
A strain for gods, denied to mortal ear.
Transmit it heard, thou silver queen of heaven!
What title or what name endears thee most?
Cynthia! Cyllene! Phœbe!—or dost hear
With higher gust fair P——d of the skies?

London, Pub.d Jan. 1. 1797. by R.Edwards. 142 New Bond St.

Is that the soft enchantment calls thee down,
More powerful than of old circean charm?
Come; but from heavenly banquets with thee bring
The soul of song, and whisper in mine ear
The theft divine; or in propitious dreams
For dreams are thine, transfuse it through the breast
Of thy first votary——but not thy last
If, like thy namesake, thou art ever kind.
　　　And kind thou wilt be; kind on such a theme—
A theme so like thee, a quite lunar theme,
Soft, modest, melancholy, female, fair—
A theme that rose all pale, and told my soul
'Twas night; on her fond hopes perpetual night;
A night which struck a damp, a deadlier damp
Than that which smote me from PHILANDER's tomb.
NARCISSA follows, ere his tomb is closed.
Woes cluster; rare are solitary woes;
They love a train, they tread each other's heel:
Her death invades his mournful right, and claims
The grief that started from my lids for him;
Seizes the faithless, alienated tear,
Or shares it ere it falls.　So frequent death,
Sorrow he more than causes, he confounds;
For human sighs his rival strokes contend,
And make distress, distraction.　Oh PHILANDER!
What was thy fate? a double fate to me;
Portent and pain! a menace and a blow!
Like the black raven hovering o'er my peace,
Not less a bird of omen than of prey:
It call'd NARCISSA long before her hour;

It call'd her tender soul by break of bliss,
From the first blossom, from the buds of joy—
Those few our noxious fate unblasted leaves
In this inclement clime of human life.

 Sweet harmonist! and beautiful as sweet—
And young as beautiful—and soft as young—
And gay as soft—and innocent as gay—
And happy, if aught happy here, as good!
For fortune fond had built her nest on high.
Like birds quite exquisite of note and plume,
Transfix'd by fate who loves a lofty mark,
How from the summit of the grove she fell
And left it inharmonious! all its charm
Extinguish'd in the wonders of her song!
Her song still vibrates in my ravish'd ear
Still melting there, and with voluptuous pain
O to forget her! thrilling through my heart!

 Song, beauty, youth, love, virtue, joy! this group
Of bright ideas, flowers of paradise
As yet unforfeit! in one blaze we bind,
Kneel, and present it to the skies as all
We guess of heaven: and these were all her own,
And she was mine; and I was—was!—most blest—
Gay title of the deepest misery!
As bodies grow more pond'rous robb'd of life;
Good lost weighs more in grief, than gain'd in joy:
Like blossom'd trees o'erturn'd by vernal storm,
Lovely in death the beauteous ruin lay;
And if in death still lovely, lovelier there
Far lovelier! pity swells the tide of love.

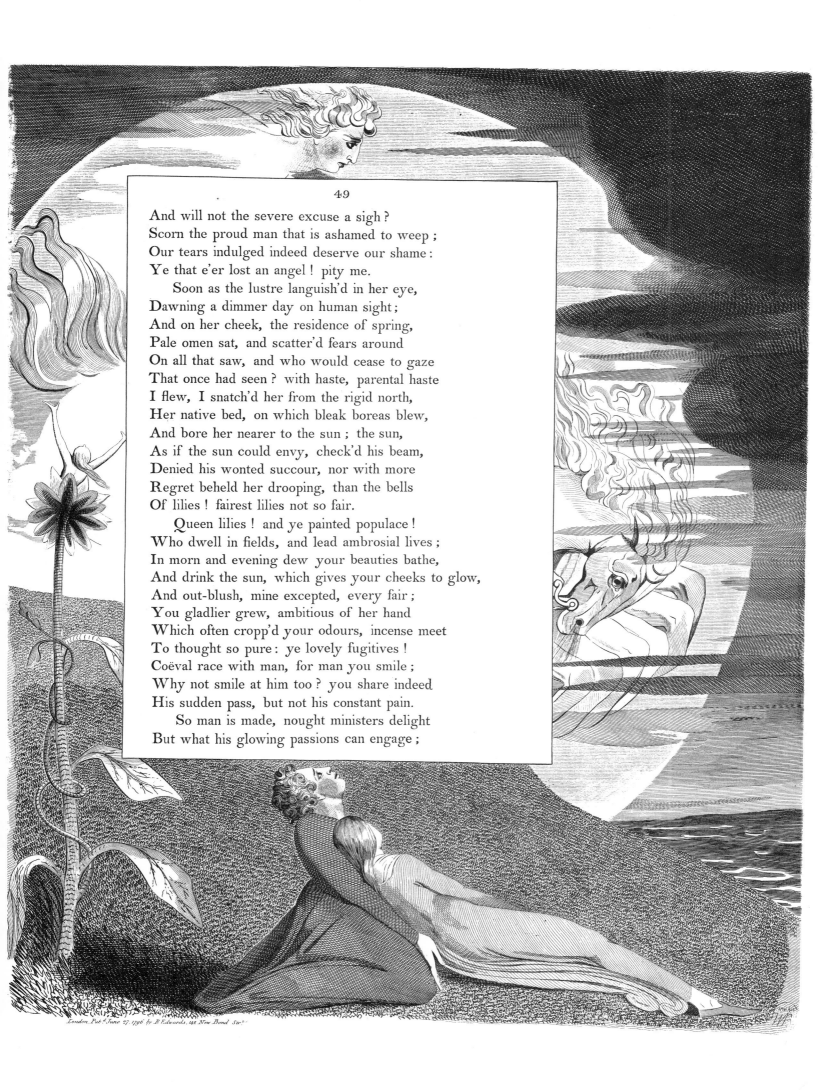

49

And will not the severe excuse a sigh?
Scorn the proud man that is ashamed to weep;
Our tears indulged indeed deserve our shame:
Ye that e'er lost an angel! pity me.

　Soon as the lustre languish'd in her eye,
Dawning a dimmer day on human sight;
And on her cheek, the residence of spring,
Pale omen sat, and scatter'd fears around
On all that saw, and who would cease to gaze
That once had seen? with haste, parental haste
I flew, I snatch'd her from the rigid north,
Her native bed, on which bleak boreas blew,
And bore her nearer to the sun; the sun,
As if the sun could envy, check'd his beam,
Denied his wonted succour, nor with more
Regret beheld her drooping, than the bells
Of lilies! fairest lilies not so fair.

　Queen lilies! and ye painted populace!
Who dwell in fields, and lead ambrosial lives;
In morn and evening dew your beauties bathe,
And drink the sun, which gives your cheeks to glow,
And out-blush, mine excepted, every fair;
You gladlier grew, ambitious of her hand
Which often cropp'd your odours, incense meet
To thought so pure: ye lovely fugitives!
Coëval race with man, for man you smile;
Why not smile at him too? you share indeed
His sudden pass, but not his constant pain.

　So man is made, nought ministers delight
But what his glowing passions can engage;

London, Pub.ᵈ June 27. 1796 by R. Edwards, 142 New Bond Str.ᵗ

And glowing passions bent on aught below
Must, soon or late, with anguish turn the scale;
And anguish after rapture how severe!
Rapture? bold man! who tempts the wrath divine
By plucking fruit denied to mortal taste;
Whilst here presuming on the rights of heaven.
For transport dost thou call on every hour,
Lorenzo? at thy friend's expense be wise:
Lean not on earth, 'twill pierce thee to the heart;
A broken reed at best, but oft a spear;
On its sharp point peace bleeds, and hope expires.

 Turn, hopeless thought! turn from her: thought repell'd
Resenting rallies, and wakes every woe.
Snatch'd ere thy prime! and in thy bridal hour!
And when kind fortune with thy lover smiled!
And when high-flavour'd thy fresh opening joys!
And when blind man pronounced thy bliss complete!
And on a foreign shore, where strangers wept!
Strangers to thee; and, more surprising still,
Strangers to kindness wept; their eyes let fall
Inhuman tears, strange tears that trickled down
From marble hearts! obdurate tenderness!
A tenderness that call'd them more severe;
In spite of nature's soft persuasion, steel'd:
While nature melted, superstition raved;
That mourn'd the dead,—and this denied a grave.

 Their sighs incensed, sighs foreign to the will!
Their will the tiger suck'd, out-raged the storm:
For, oh the cursed ungodliness of zeal!
While sinful flesh relented, spirit nursed

In blind infallibility's embrace,
The sainted spirit petrified the breast,
Denied the charity of dust to spread
O'er dust!—a charity their dogs enjoy.
What could I do ? what succour ? what resource ?
With pious sacrilege a grave I stole;
With impious piety that grave I wrong'd :
Short in my duty, coward in my grief,
More like her murderer than friend, I crept
With soft-suspended step ; and, muffled deep
In midnight darkness, whisper'd my last sigh:
I whisper'd what should echo through their realms ;
Nor writ her name, whose tomb should pierce the skies.
Presumptuous fear ! how durst I dread her foes,
While nature's loudest dictates I obey'd ?
Pardon necessity, blest shade ! of grief
And indignation rival bursts I pour'd ;
Half-execration mingled with my prayer,
Kindled at man, while I his GOD adored ;
Sore grudged the savage land her sacred dust;
Stamped the cursed soil ; and, with humanity,
Denied NARCISSA, wish'd them all a grave.

 Glows my resentment into guilt ? what guilt
Can equal violations of the dead ?
The dead how sacred ! sacred is the dust
Of this heaven-labour'd form, erect, divine !
This heaven-assumed majestic robe of earth
He deign'd to wear, who hung the vast expanse
With azure bright, and clothed the sun in gold.
When every passion sleeps that can offend ;

When strikes us every motive that can melt;
When man can wreak his rancour uncontroll'd,
That strongest curb on insult and ill-will;
Then, spleen to dust! the dust of innocence!
An angel's dust!—this Lucifer transcends;
When he contended for the patriarch's bones,
'Twas not the strife of malice, but of pride;
The strife of pontiff pride, not pontiff gall.

 Far less than this is shocking in a race
Most wretched, but from streams of mutual love;
And uncreated, but for love divine;
And, but for love divine, this moment lost,
By fate resorb'd, and sunk in endless night.
Man hard of heart to man! of horrid things
Most horrid! 'mid stupendous highly strange!
Yet oft his courtesies are smoother wrongs;
Pride brandishes the favours he confers,
And contumelious his humanity:
What then his vengeance? hear it not, ye stars!
And thou, pale moon! turn paler at the sound;
Man is to man the sorest, surest ill.
A previous blast foretels the rising storm;
O'erwhelming turrets threaten ere they fall;
Volcanos bellow ere they disembogue;
Earth trembles ere her yawning jaws devour;
And smoke betrays the wide-consuming fire:
Ruin from man is most conceal'd when near,
And sends the dreadful tidings in the blow.
Is this the flight of fancy? would it were!

Heaven's SOVEREIGN saves all beings but himself
That hideous sight, a naked human heart.

 Fired is the muse ? and let the muse be fired :
Who not inflamed, when what he speaks he feels,
And in the nerve most tender, in his friends ?
Shame to mankind ! PHILANDER had his foes :
He felt the truths I sing, and I in him.
But he, nor I feel more : past ills, NARCISSA !
Are sunk in thee, thou recent wound of heart
Which bleeds with other cares ! with other pangs ;
Pangs numerous, as the numerous ills that swarm'd
O'er thy distinguish'd fate, and, clustering there
Thick as the locust on the land of Nile,
Made death more deadly, and more dark the grave.
Reflect, if not forgot my touching tale,
How was each circumstance with aspicks arm'd !
An aspick each, and all an hydra-woe.
What strong herculean virtue could suffice ?—
Or is it virtue to be conquer'd here ?
This hoary cheek a train of tears bedews ;
And each tear mourns its own distinct distress ;
And each distress, distinctly mourn'd, demands
Of grief still more, as heighten'd by the whole.
A grief like this proprietors excludes :
Not friends alone such obsequies deplore ;
They make mankind the mourner, carry sighs
Far as the fatal fame can wing her way,
And turn the gayest thought of gayest age
Down the right channel through the vale of death—
* The vale of death ! that hush'd cimmerian vale,

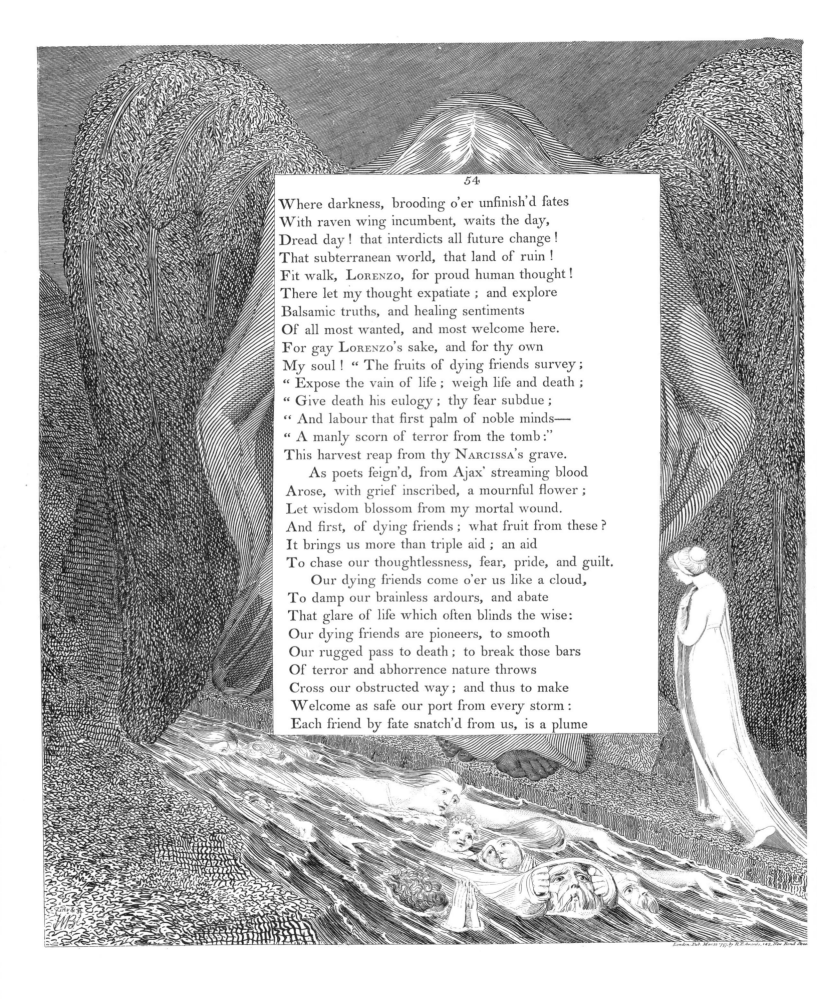

54

Where darkness, brooding o'er unfinish'd fates
With raven wing incumbent, waits the day,
Dread day! that interdicts all future change!
That subterranean world, that land of ruin!
Fit walk, Lorenzo, for proud human thought!
There let my thought expatiate; and explore
Balsamic truths, and healing sentiments
Of all most wanted, and most welcome here.
For gay Lorenzo's sake, and for thy own
My soul! " The fruits of dying friends survey;
" Expose the vain of life; weigh life and death;
" Give death his eulogy; thy fear subdue;
" And labour that first palm of noble minds—
" A manly scorn of terror from the tomb:"
This harvest reap from thy Narcissa's grave.

As poets feign'd, from Ajax' streaming blood
Arose, with grief inscribed, a mournful flower;
Let wisdom blossom from my mortal wound.
And first, of dying friends; what fruit from these?
It brings us more than triple aid; an aid
To chase our thoughtlessness, fear, pride, and guilt.
Our dying friends come o'er us like a cloud,
To damp our brainless ardours, and abate
That glare of life which often blinds the wise:
Our dying friends are pioneers, to smooth
Our rugged pass to death; to break those bars
Of terror and abhorrence nature throws
Cross our obstructed way; and thus to make
Welcome as safe our port from every storm:
Each friend by fate snatch'd from us, is a plume

London, Pub. Mar 22 1797, by R.Edwards, 142, New Bond Stree

Pluck'd from the wing of human vanity,
Which makes us stoop from our aërial heights,
And, damp'd with omen of our own decease,
On drooping pinions of ambition lower'd,
Just skim earth's surface, ere we break it up,
O'er putrid earth to scratch a little dust,
And save the world a nuisance : smitten friends
Are angels sent on errands full of love :
For us they languish, and for us they die :
And shall they languish, shall they die in vain ?
* Ungrateful, shall we grieve their hovering shades
Which wait the revolution in our hearts ?
Shall we disdain their silent soft address,
Their posthumous advice, and pious prayer ?
Senseless as herds that graze their hallow'd graves,
Tread under foot their agonies and groans,
Frustrate their anguish, and destroy their deaths ?
 Lorenzo ! no ; the thought of death indulge ;
Give it its wholesome empire—let it reign,
That kind chastiser of thy soul in joy ;
Its reign will spread thy glorious conquests far,
And still the tumults of thy ruffled breast :
Auspicious æra ! golden days, begin !
The thought of death shall, like a god, inspire.
And why not think on death ? is life the theme
Of every thought ? and wish of every hour ?
And song of every joy ? Surprising truth !
The beaten spaniel's fondness not so strange.
To wave the numerous ills that seize on life
As their own property, their lawful prey ;

Ere man has measured half his weary stage,
His luxuries have left him no reserve,
No maiden relishes, unbroach'd delights;
On cold-served repetitions he subsists,
And in the tasteless present chews the past;
Disgusted chews, and scarce can swallow down:
Like lavish ancestors, his earlier years
Have disinherited his future hours,
Which starve on orts, and glean their former field.
　　Live ever here, LORENZO!—Shocking thought!
So shocking, they who wish, disown it too;
Disown from shame, what they from folly crave.
Live ever in the womb, nor see the light!
For what live ever here?—With labouring step
To tread our former footsteps? pace the round
Eternal? to climb life's worn, heavy wheel,
Which draws up nothing new? to beat and beat
The beaten track? to bid each wretched day
The former mock? to surfeit on the same,
And yawn our joys? or thank a misery
For change, though sad? to see what we have seen?
Hear, till unheard, the same old slabber'd tale?
To taste the tasted, and at each return
Less tasteful? o'er our palates to decant
Another vintage? strain a flatter year,
Through loaded vessels, and a laxer tone?
Crazy machines to grind earth's wasted fruits!
Ill-ground, and worse concocted! load, not life!
The rational foul kennels of excess!

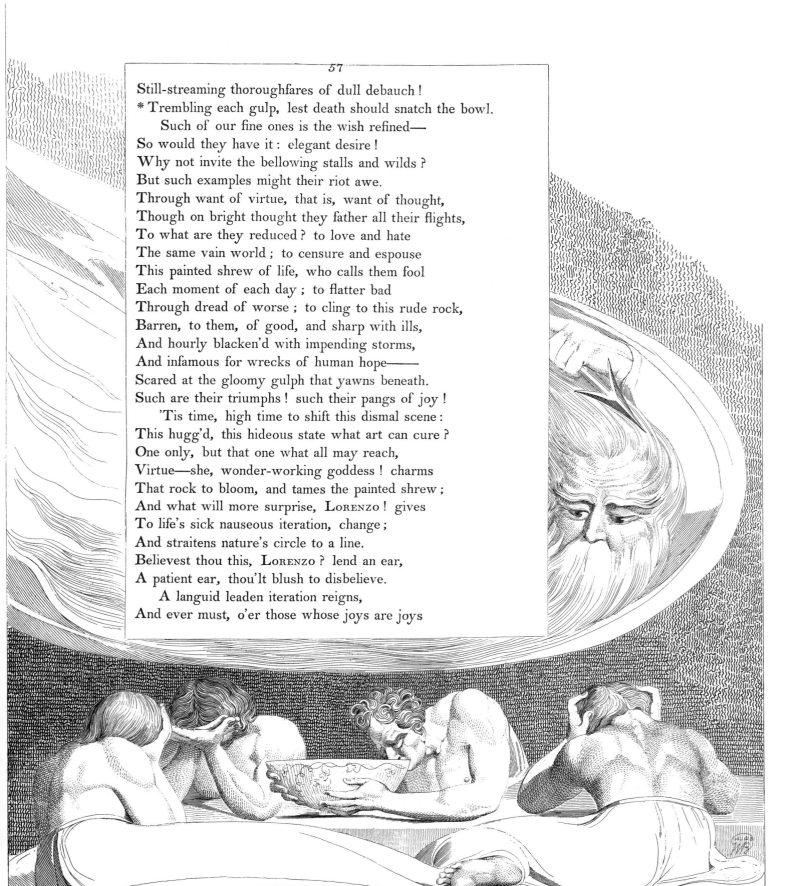

Still-streaming thoroughfares of dull debauch!
* Trembling each gulp, lest death should snatch the bowl.
 Such of our fine ones is the wish refined—
So would they have it : elegant desire!
Why not invite the bellowing stalls and wilds?
But such examples might their riot awe.
Through want of virtue, that is, want of thought,
Though on bright thought they father all their flights,
To what are they reduced? to love and hate
The same vain world; to censure and espouse
This painted shrew of life, who calls them fool
Each moment of each day; to flatter bad
Through dread of worse; to cling to this rude rock,
Barren, to them, of good, and sharp with ills,
And hourly blacken'd with impending storms,
And infamous for wrecks of human hope——
Scared at the gloomy gulph that yawns beneath.
Such are their triumphs! such their pangs of joy!
 'Tis time, high time to shift this dismal scene:
This hugg'd, this hideous state what art can cure?
One only, but that one what all may reach,
Virtue—she, wonder-working goddess! charms
That rock to bloom, and tames the painted shrew;
And what will more surprise, LORENZO! gives
To life's sick nauseous iteration, change;
And straitens nature's circle to a line.
Believest thou this, LORENZO? lend an ear,
A patient ear, thou'lt blush to disbelieve.
 A languid leaden iteration reigns,
And ever must, o'er those whose joys are joys

Of sight, smell, taste: the cuckow-seasons sing
The same dull note to such as nothing prize
But what those seasons from the teeming earth
To doating sense indulge: but nobler minds,
Which relish fruits unripen'd by the sun,
Make their days various; various as the dyes
On the dove's neck, which wanton in his rays:
On minds of dove-like innocence possess'd,
On lighten'd minds that bask in virtue's beams,
Nothing hangs tedious, nothing old revolves
In that for which they long, for which they live:
Their glorious efforts wing'd with heavenly hope,
Each rising morning sees still higher rise;
Each bounteous dawn its novelty presents
To worth maturing, new strength, lustre, fame;
While nature's circle, like a chariot-wheel
Rolling beneath their elevated aims,
Makes their fair prospect fairer every hour,
Advancing virtue in a line to bliss;
Virtue—which christian motives best inspire!
And bliss—which christian schemes alone ensure!
 And shall we then, for virtue's sake, commence
Apostates? and turn infidels for joy?
A truth it is few doubt, but fewer trust,
" He sins against this life who slights the next."
What is this life? how few their favourite know!
Fond in the dark, and blind in our embrace,
By passionately loving life, we make
Loved life unlovely; hugging her to death:
We give to time eternity's regard;

And, dreaming, take our passage for our port :
Life has no value as an end, but means ;
An end deplorable ! a means divine !
When 'tis our all, 'tis nothing ; worse than nought—
A nest of pains ; when held as nothing, much :
Like some fair humourists, life is most enjoy'd
When courted least ; most worth, when disesteem'd ;
Then 'tis the seat of comfort ; rich in peace,
In prospect richer far ; important ! awful !
Not to be mention'd, but with shouts of praise !
Not to be thought on, but with tides of joy !—
The mighty basis of eternal bliss !

Where now the barren rock, the painted shrew ?
Where now, LORENZO ! life's eternal round ?
Have I not made my triple promise good ?
Vain is the world ; but only to the vain.
To what compare we then this varying scene,
Whose worth ambiguous rises and declines,
Waxes and wanes ? In all propitious, night
Assists me here : compare it to the moon
Dark in herself, and indigent ; but rich
In borrow'd lustre from a higher sphere :
When gross guilt interposes, labouring earth
O'ershadow'd mourns a deep eclipse of joy ;
Her joys, at brightest pallid to that font
Of full effulgent glory, whence they flow.

Nor is that glory distant : oh LORENZO !
A good man and an angel, these between
How thin the barrier ! what divides their fate ?
Perhaps a moment, or perhaps a year ;

Or, if an age, it is a moment still ;
A moment, or eternity 's forgot.
Then be, what once they were who now are gods ;
Be what PHILANDER was, and claim the skies.
Starts timid nature at the gloomy pass ?
The soft transition call it, and be cheer'd :
Such it is often, and why not to thee ?
To hope the best is pious, brave, and wise ;
And may itself procure what it presumes :
Life is much flatter'd, death is much traduced ;
Compare the rivals, and the kinder crown.
" Strange competition !"—True, LORENZO ! strange !
So little life can cast into the scale.

 Life makes the soul dependent on the dust ;
Death gives her wings to mount above the spheres :
Through chinks stiled organs, dim life peeps at light ;
Death bursts the involving cloud, and all is day ;
All eye, all ear the disembodied power.
Death has feign'd evils nature shall not feel ;
Life, ills substantial wisdom cannot shun.
Is not the mighty mind, that son of heaven !
By tyrant life dethroned, imprison'd, pain'd ?
By death enlarged, ennobled, deified ?
Death but entombs the body ;—life the soul.

 " Is death then guiltless ? how he marks his way
" With dreadful waste of what deserves to shine !
" Art, genius, fortune, elevated power !
" With various lustres these light up the world,
" Which death puts out, and darkens human race."
I grant, LORENZO ! this indictment just :

The sage, peer, potentate, king, conqueror!
Death humbles these; more barb'rous life, the man:
Life is the triumph of our mould'ring clay;
Death of the spirit infinite—divine!
Death has no dread, but what frail life imparts;
Nor life true joy, but what kind death improves:
No bliss has life to boast, till death can give
Far greater; life's a debtor to the grave,
Dark lattice! letting in eternal day.

 LORENZO! blush at fondness for a life
Which sends celestial souls on errands vile,
To cater for the sense; and serve at boards
Where every ranger of the wilds, perhaps
Each reptile justly claims our upper hand:
Luxurious feast! a soul—a soul immortal
In all the dainties of a brute bemired!
LORENZO! blush at terror for a death
Which gives thee to repose in festive bowers,
Where nectars sparkle, angels minister,
And more than angels share, and raise, and crown,
And eternize the birth, bloom, bursts of bliss.
What need I more? O death, the palm is thine.

 Then welcome, death! thy dreaded harbingers
* Age and disease; disease, though long my guest
That plucks my nerves, those tender strings of life,
Which, pluck'd a little more, will toll the bell
That calls my few friends to my funeral;
Where feeble nature drops, perhaps, a tear;
While reason and religion, better taught,
Congratulate the dead, and crown his tomb

With wreath triumphant: death is victory;
It binds in chains the raging ills of life:
Lust and ambition, wrath and avarice,
Dragg'd at his chariot-wheel, applaud his power.
That ills corrosive, cares importunate
Are not immortal too, O death! is thine.
Our day of dissolution!—name it right
'Tis our great pay-day, 'tis our harvest rich
And ripe: what though the sickle, sometimes keen,
Just scars us as we reap the golden grain;
More than thy balm, O Gilead! heals the wound.
Birth's feeble cry, and death's deep dismal groan
Are slender tributes low-tax'd nature pays
For mighty gain: the gain of each, a life!
But O! the last the former so transcends,
Life dies compared! life lives beyond the grave.
　　　And feel I, death! no joy from thought of thee?
Death, the great counsellor, who man inspires
With nobler thought, and fairer deed!
Death, the deliverer, who rescues man!
Death, the rewarder, who the rescued crowns!
Death, that absolves my birth, a curse without it!
Rich death, that realizes all my cares,
Toils, virtues, hopes;—without it a chimera!
Death, of all pain the period, not of joy;
Joy's source and subject still subsist unhurt,
One in my soul, and one in her great sire;
Though the four winds were warring for my dust:
Yes, and from winds, and waves, and central night,
Though prison'd there, my dust too I reclaim,

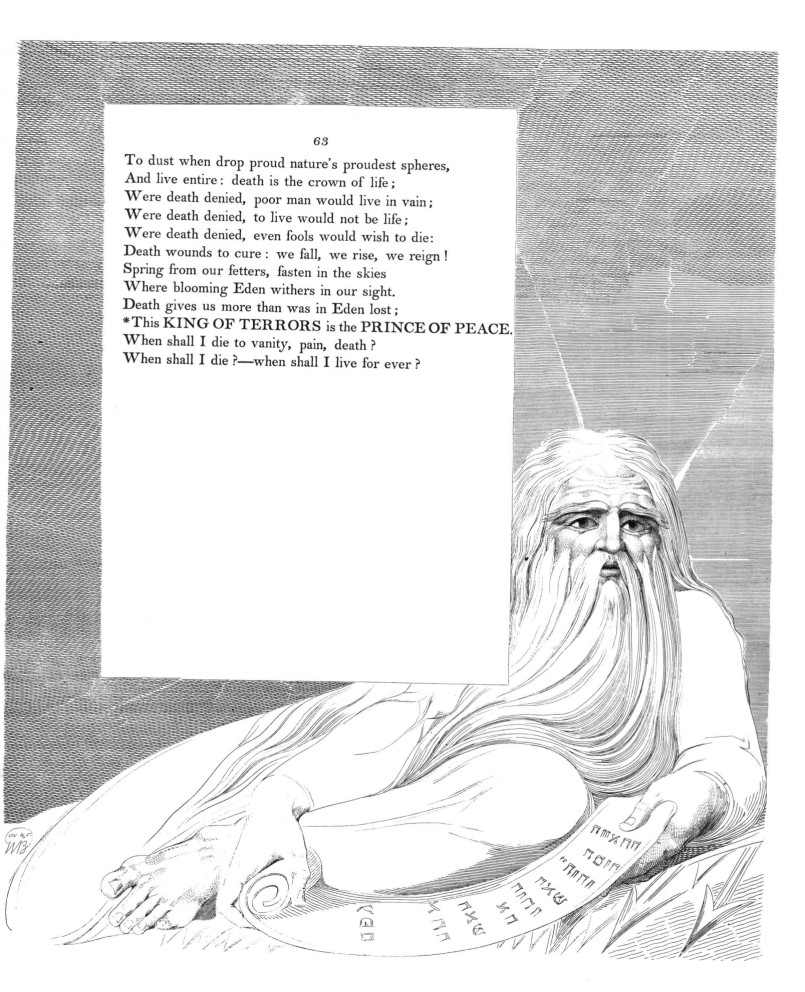

63

To dust when drop proud nature's proudest spheres,
And live entire: death is the crown of life;
Were death denied, poor man would live in vain;
Were death denied, to live would not be life;
Were death denied, even fools would wish to die:
Death wounds to cure: we fall, we rise, we reign!
Spring from our fetters, fasten in the skies
Where blooming Eden withers in our sight.
Death gives us more than was in Eden lost;
*This **KING OF TERRORS** is the **PRINCE OF PEACE.**
When shall I die to vanity, pain, death?
When shall I die?—when shall I live for ever?

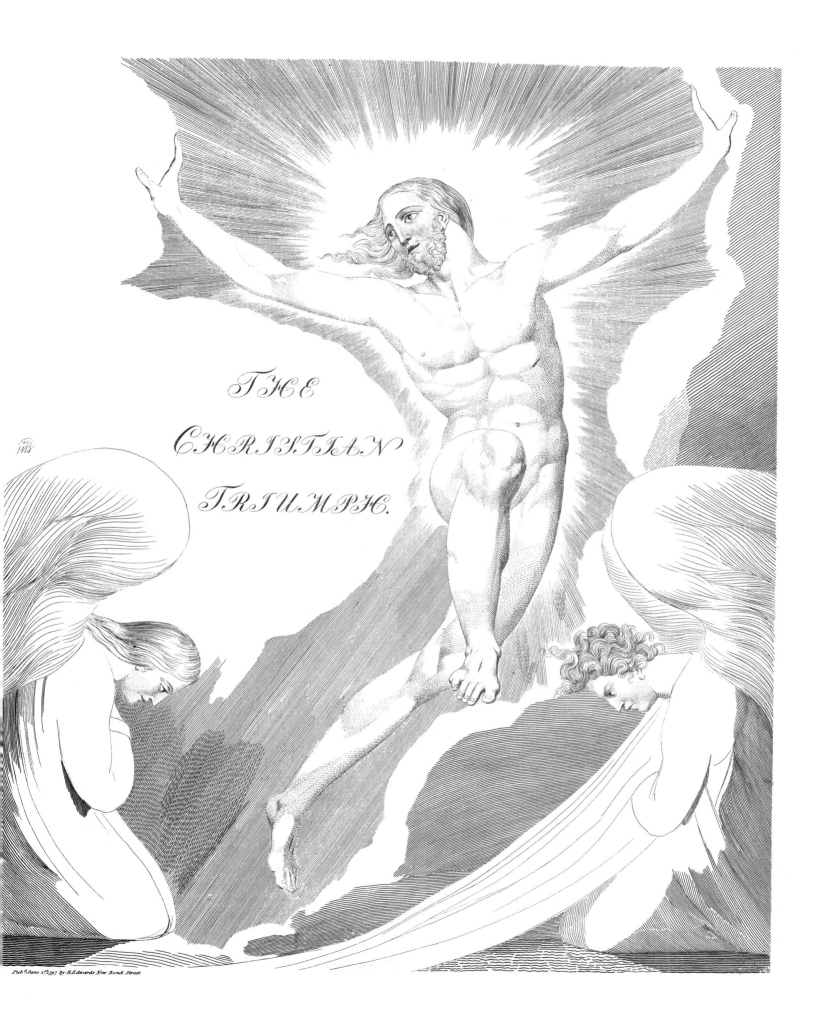

THE

CHRISTIAN

TRIUMPH.

Pub.d June 1.st 1797 by R.Edwards New Bond Street

NIGHT THE FOURTH.

A Much-indebted muse, O Yorke! intrudes:
Amid the smiles of fortune, and of youth,
Thine ear is patient of a serious song.
How deep implanted in the breast of man
The dread of death! I sing its sovereign cure.

 Why start at death? Where is he? death arrived
Is past; not come, or gone, he's never here.
Ere hope, sensation fails; black-boding man
Receives, not suffers death's tremendous blow:
The knell, the shroud, the mattock and the grave;
The deep damp vault, the darkness and the worm;
These are the bugbears of a winter's eve,
The terrors of the living, not the dead.
Imagination's fool, and error's wretch
Man makes a death, which nature never made;
Then on the point of his own fancy falls,
And feels a thousand deaths in fearing one.

But were death frightful, what has age to fear ?
If prudent, age should meet the friendly foe,
And shelter in his hospitable gloom.
I scarce can meet a monument but holds
My younger ; every date cries—" come away:"
And what recalls me ? look the world around
And tell me what : the wisest cannot tell.
Should any born of woman give his thought
Full range on just dislike's unbounded field ;
" Of things—the vanity ; of men—the flaws ;"
Flaws in the best, the many flaw all o'er ;
As leopards, spotted, or, as Æthiops, dark ;
Vivacious, ill ; good, dying immature ;
How immature NARCISSA's marble tells,
And at its death bequeathing endless pain ;
His heart, though bold, would sicken at the sight,
And spend itself in sighs for future scenes.
　　　　But grant to life, and just it is to grant
To lucky life, some perquisites of joy ;
A time there is, when, like a thrice-told tale,
Long-rifled life of sweet can yield no more,
But from our comment on the comedy,
Pleasing reflections on parts well-sustain'd ;
Or purposed emendations where we fail'd,
Or hopes of plaudits from our candid judge ;
When, on their exit, souls are bid unrobe,
Toss fortune back her tinsel, and her plume,
And drop this mask of flesh behind the scene :
With me that time is come ; my world is dead ;
A new world rises, and new manners reign :

Foreign comedians, a spruce band, arrive,
To push me from the scene, or hiss me there :
What a pert race starts up ! the strangers gaze,
And I at them ; my neighbour is unknown ;
Nor that the worst : ah me ! the dire effect
Of loitering here, of death defrauded long ;
Of old so gracious, and let that suffice,
My very master knows me not.——

 Shall I dare say, peculiar is the fate ?
I've been so long remember'd, I'm forgot.
An object ever pressing dims the sight,
And hides behind its ardor to be seen:
When in his courtiers' ears I pour my plaint,
They drink it as the nectar of the great,
And squeeze my hand, and beg me come to-morrow ;
Refusal ! canst thou wear a smoother form ?

 Indulge me, nor conceive I drop my theme ;
Who cheapens life, abates the fear of death :
Twice-told the period spent on stubborn Troy,
Court-favour, yet untaken, I besiege ;
Ambition's ill-judged effort to be rich :
Alas ! ambition makes my little less,
Embittering the possess'd : why wish for more ?
Wishing, of all employments is the worst;
Philosophy's reverse, and health's decay !
Were I as plump as stall'd theology,
Wishing would waste me to this shade again :
Were I as wealthy as a south-sea dream,
Wishing is an expedient to be poor :
Wishing, that constant hectic of a fool

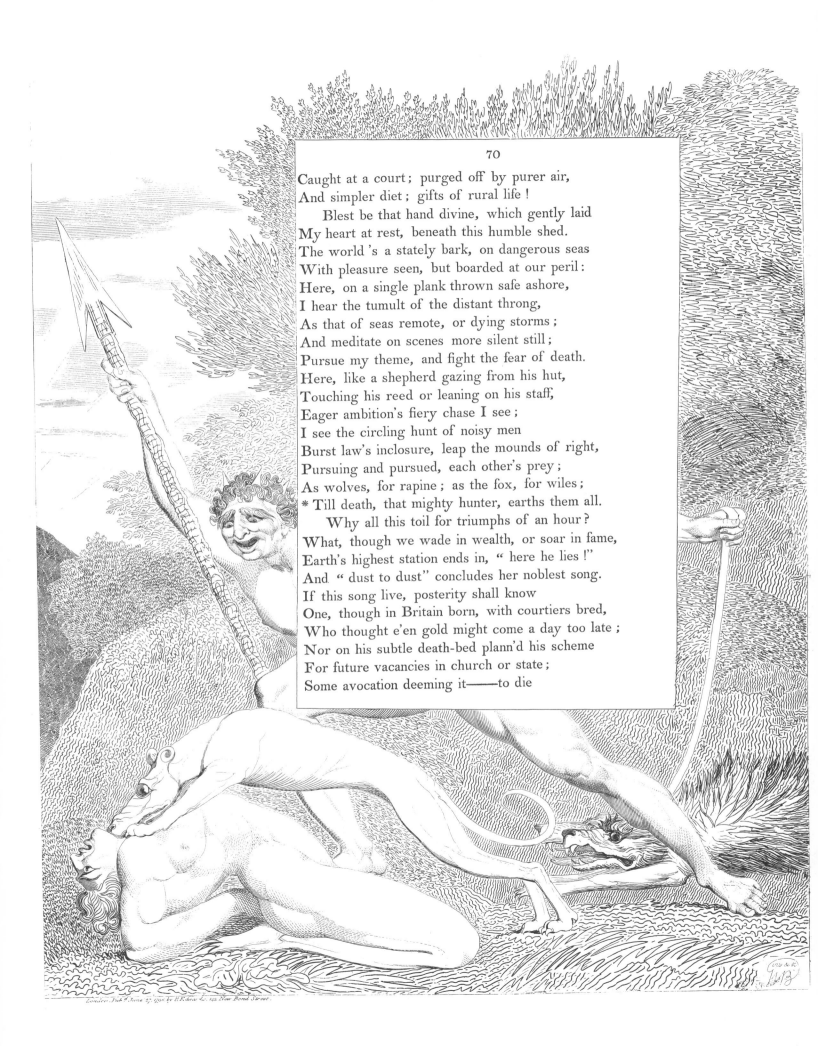

Caught at a court; purged off by purer air,
And simpler diet; gifts of rural life!

 Blest be that hand divine, which gently laid
My heart at rest, beneath this humble shed.
The world's a stately bark, on dangerous seas
With pleasure seen, but boarded at our peril:
Here, on a single plank thrown safe ashore,
I hear the tumult of the distant throng,
As that of seas remote, or dying storms;
And meditate on scenes more silent still;
Pursue my theme, and fight the fear of death.
Here, like a shepherd gazing from his hut,
Touching his reed or leaning on his staff,
Eager ambition's fiery chase I see;
I see the circling hunt of noisy men
Burst law's inclosure, leap the mounds of right,
Pursuing and pursued, each other's prey;
As wolves, for rapine; as the fox, for wiles;
* Till death, that mighty hunter, earths them all.
 Why all this toil for triumphs of an hour?
What, though we wade in wealth, or soar in fame,
Earth's highest station ends in, " here he lies!"
And " dust to dust" concludes her noblest song.
If this song live, posterity shall know
One, though in Britain born, with courtiers bred,
Who thought e'en gold might come a day too late;
Nor on his subtle death-bed plann'd his scheme
For future vacancies in church or state;
Some avocation deeming it——to die

London. Pub.ᵈ June 27, 1700, by R. Edwards & 142 New Bond Street.

Unbit by rage canine of dying rich;
Guilt's blunder! and the loudest laugh of hell!
 O my coëvals! remnants of yourselves
Poor human ruins, tottering o'er the grave!
Shall we, shall aged men, like aged trees,
Strike deeper their vile root, and closer cling,
Still more enamour'd of this wretched soil?
Shall our pale wither'd hands be still stretch'd out,
Trembling at once with eagerness and age?
With avarice and convulsions grasping hard—
Grasping at air! for what has earth beside?
Man wants but little, nor that little long;
How soon must he resign his very dust
Which frugal nature lent him for an hour!
Years inexperienced rush on numerous ills;
And soon as man, expert from time, has found
The key of life, it opes the gates of death.

 When in this vale of years I backward look,
And miss such numbers, numbers too of such
Firmer in health, and greener in their age,
And stricter on their guard, and fitter far
To play life's subtle game; I scarce believe
I still survive: and am I fond of life,
Who scarce can think it possible I live?
Alive by miracle! or, what is next,
Alive by Mead! if I am still alive
Who long have buried what gives life to live,
Firmness of nerve, and energy of thought.
Life's lee is not more shallow than impure

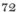

* And vapid ; sense and reason shew the door,
Call for my bier, and point me to the dust.
 O THOU ! great arbiter of life and death !
Nature's immortal, immaterial sun !
Whose all-prolific beam late call'd me forth
From darkness—teeming darkness where I lay
The worm's inferior, and in rank beneath
The dust I tread on, high to bear my brow,
To drink the spirit of the golden day,
And triumph in existence ! and couldst know
No motive but my bliss ! and hast ordain'd
A rise in blessing ! with the patriarch's joy,
Thy call I follow to the land unknown :
I trust in THEE, and know in whom I trust :
Or life or death is equal ; neither weighs ;
All weight in this—O let me live to THEE !
 Though nature's terrors thus may be repress'd ;
Still frowns grim death, guilt points the tyrant's spear :
And whence all human guilt ?—from death forgot.
Ah me ! too long I set at nought the swarm
Of friendly warnings which around me flew ;
And smiled unsmitten : small my cause to smile !
Death's admonitions, like shafts upward shot,
More dreadful by delay ; the longer ere
They strike our hearts, the deeper is their wound :
O think how deep, LORENZO ! here it stings :
Who can appease its anguish ? how it burns !
What hand the barb'd, envenom'd thought can draw ?
What healing hand can pour the balm of peace,
And turn my sight undaunted on the tomb ?

Pub.d June 1.st 1797, by R.Edwards, N.o 142 New Bond Street.

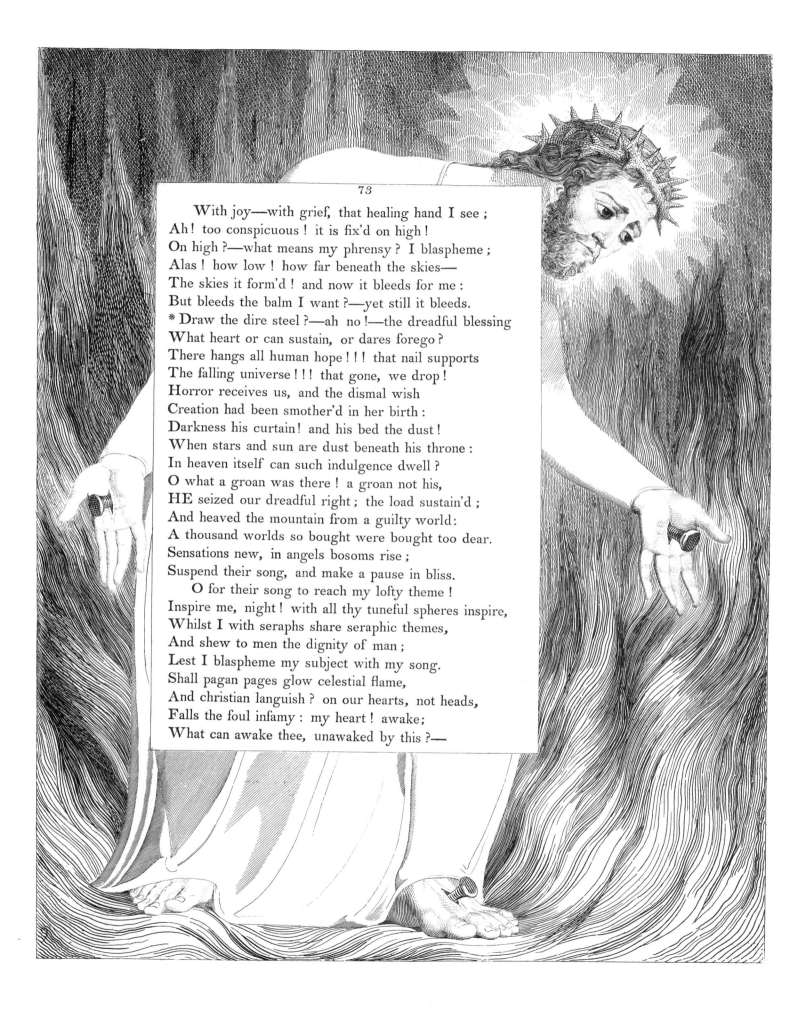

73

With joy—with grief, that healing hand I see;
Ah! too conspicuous! it is fix'd on high!
On high?—what means my phrensy? I blaspheme;
Alas! how low! how far beneath the skies—
The skies it form'd! and now it bleeds for me:
But bleeds the balm I want?—yet still it bleeds.
* Draw the dire steel?—ah no!—the dreadful blessing
What heart or can sustain, or dares forego?
There hangs all human hope!!! that nail supports
The falling universe!!! that gone, we drop!
Horror receives us, and the dismal wish
Creation had been smother'd in her birth:
Darkness his curtain! and his bed the dust!
When stars and sun are dust beneath his throne:
In heaven itself can such indulgence dwell?
O what a groan was there! a groan not his,
HE seized our dreadful right; the load sustain'd;
And heaved the mountain from a guilty world:
A thousand worlds so bought were bought too dear.
Sensations new, in angels bosoms rise;
Suspend their song, and make a pause in bliss.
 O for their song to reach my lofty theme!
Inspire me, night! with all thy tuneful spheres inspire,
Whilst I with seraphs share seraphic themes,
And shew to men the dignity of man;
Lest I blaspheme my subject with my song.
Shall pagan pages glow celestial flame,
And christian languish? on our hearts, not heads,
Falls the foul infamy: my heart! awake;
What can awake thee, unawaked by this?—

" Expended DEITY on human weal."
Feel the great truths, which burst the tenfold night
Of heathen error with a golden flood
Of endless day : to feel is to be fired ;
And to believe, LORENZO ! is to feel.

 Thou most indulgent, most tremendous power !
Still more tremendous for thy wondrous love !
That, arms with awe more aweful thy commands ;
And foul transgression dips in sevenfold night :
How our hearts tremble at thy love immense !
In love immense, inviolably just !
THOU, rather than thy justice should be stain'd,
Didst stain the cross ; and, work of wonders far
The greatest—that thy dearest far might bleed !

 Bold thought ! shall I dare speak it, or repress ?
Should man more execrate, or boast the guilt
Which roused such vengeance ? which such love inflamed ?
O'er guilt, how mountainous, with out-stretch'd arms
Stern justice, and soft-smiling love embrace ;
Supporting in full majesty thy throne,
When seem'd its majesty to need support,
Or that, or man inevitably lost.
What, but the fathomless of thought divine,
Could labour such expedient from despair,
And rescue both ? both rescue—both exalt !
O how are both exalted by the deed—
The wondrous deed ! or shall I call it more ?
A wonder in OMNIPOTENCE itself !
A mystery, no less to gods than men !

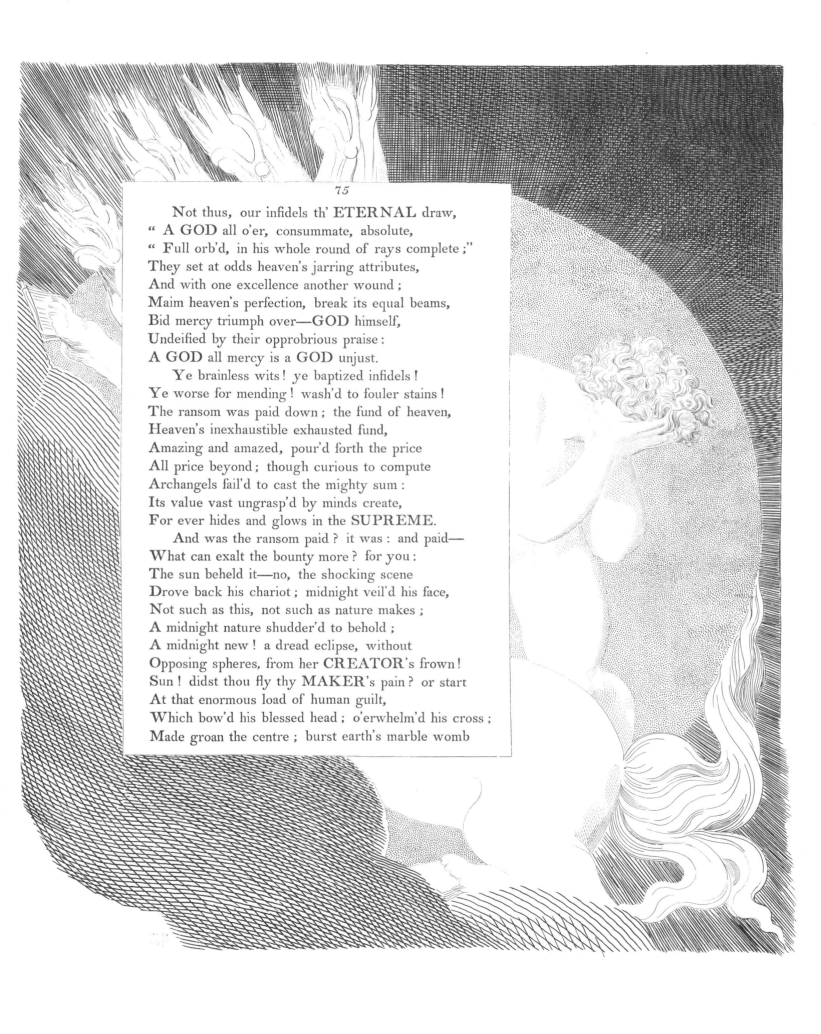

Not thus, our infidels th' ETERNAL draw,
" A GOD all o'er, consummate, absolute,
" Full orb'd, in his whole round of rays complete;"
They set at odds heaven's jarring attributes,
And with one excellence another wound;
Maim heaven's perfection, break its equal beams,
Bid mercy triumph over—GOD himself,
Undeified by their opprobrious praise:
A GOD all mercy is a GOD unjust.
 Ye brainless wits! ye baptized infidels!
Ye worse for mending! wash'd to fouler stains!
The ransom was paid down; the fund of heaven,
Heaven's inexhaustible exhausted fund,
Amazing and amazed, pour'd forth the price
All price beyond; though curious to compute
Archangels fail'd to cast the mighty sum:
Its value vast ungrasp'd by minds create,
For ever hides and glows in the SUPREME.
 And was the ransom paid? it was: and paid—
What can exalt the bounty more? for you:
The sun beheld it—no, the shocking scene
Drove back his chariot; midnight veil'd his face,
Not such as this, not such as nature makes;
A midnight nature shudder'd to behold;
A midnight new! a dread eclipse, without
Opposing spheres, from her CREATOR's frown!
Sun! didst thou fly thy MAKER's pain? or start
At that enormous load of human guilt,
Which bow'd his blessed head; o'erwhelm'd his cross;
Made groan the centre; burst earth's marble womb

With pangs—strange pangs! deliver'd of her dead?
Hell howl'd, and heaven that hour let fall a tear:
Heaven wept, that man might smile! heaven bled, that man
Might never die !———
 And is devotion virtue? 'tis compell'd:
What heart of stone but glows at thoughts like these!
Such contemplations mount us; and should mount
The mind still higher; nor ever glance on man,
Unraptured, uninflamed.—Where roll my thoughts
To rest from wonders? other wonders rise,
And strike where'er they roll; my soul is caught:
Heaven's sovereign blessings, clust'ring from the cross,
Rush on her in a throng, and close her round
The prisoner of amaze !———In his blest life
I see the path, and in his death the price,
And in his great ascent the proof supreme
Of immortality :———and did HE rise?
Hear, O ye nations! hear it, O ye dead!
He rose! he rose! he burst the bars of death:
Lift up your heads, ye everlasting gates!
And give the **KING OF GLORY** to come in:
Who is the king of glory? HE who left
His throne of glory for the pang of death:
Lift up your heads, ye everlasting gates!
And give the **KING OF GLORY** to come in:
Who is the king of glory? HE who slew
The ravenous foe that gorged all human race !
The **KING OF GLORY HE,** whose glory fill'd
Heaven with amazement at his love to man ;

And with divine complacency beheld
Powers most illumined, wilder'd in the theme.
 The theme, the joy how then shall man sustain?
Oh the burst gates ! crush'd sting ! demolish'd throne !
Last gasp of vanquish'd death ! shout earth and heaven !
This sum of good to man, whose nature then
Took wing, and mounted with HIM from the tomb !
Then, then I rose ; then first humanity
Triumphant past the crystal ports of light,
Stupendous guest ! and seized eternal youth;
Seized in our name : e'er since, 'tis blasphemous
To call man mortal : man's mortality
Was then transferr'd to death; and heaven's duration
Unalienably seal'd to this frail frame,
This child of dust :—man all-immortal, hail !
Hail, heaven ! all-lavish of strange gifts to man !
Thine all the glory; man's the boundless bliss.
 Where am I rapt by this triumphant theme,
On christian joy's exulting wing above
Th' Aonian mount ?—alas, small cause for joy !
What if to pain immortal ? if extent
Of being, to preclude a close of woe—
Where then my boast of immortality ?
I boast it still, though cover'd o'er with guilt :
For guilt, not innocence his life he pour'd !
'Tis guilt alone can justify his death ;
Nor that, unless his death can justify
Relenting guilt in heaven's indulgent sight.
If, sick of folly, I relent; he writes
My name in heaven with that inverted spear,

A spear deep-dipt in blood! which pierced his side,
And open'd there a font for all mankind
Who strive, who combat crimes; to drink and live:
This, only this subdues the fear of death.

 And what is this?—survey the wondrous cure;
And at each step let higher wonder rise:
" Pardon for infinite offence! and pardon
" Through means that speak its value infinite!
" A pardon bought with blood! with blood divine!
" With blood divine of HIM I made my foe!
" Persisted to provoke! though woo'd and awed,
" Blest and chastised, a flagrant rebel still!
" A rebel, 'midst the thunders of his throne!
" Nor I alone, a rebel universe!
" My species up in arms! not one exempt!
" Yet for the foulest of the foul HE dies;
" Most joy'd for the redeem'd from deepest guilt!
" As if our race were held of highest rank;
" And godhead dearer, as more kind to man!"
 Bound every heart! and every bosom burn!
Oh what a scale of miracles is here!
Its lowest round high planted on the skies;
Its towering summit lost beyond the thought
Of man or angel! oh that I could climb
The wonderful ascent with equal praise!
Praise! flow for ever; if astonishment
Will give thee leave, my praise! for ever flow;
Praise ardent, cordial, constant, to high heaven
More fragrant than Arabia sacrificed;
And all her spicy mountains in a flame.

So dear, so due to heaven, shall praise descend
With her soft plume, from plausive angels' wing
First pluck'd by man, to tickle mortal ears,
Thus diving in the pockets of the great?
Is praise the perquisite of every paw,
Though black as hell, that grapples well for gold?
Oh love of gold! thou meanest of amours!
Shall praise her odours waste on virtues dead?
Embalm the base, perfume the stench of guilt,
Earn dirty bread by washing Ethiops fair,
Removing filth or sinking it from sight,
A scavenger in scenes where vacant posts,
Like gibbets yet untenanted, expect
Their future ornaments?—from courts and thrones,
Return, apostate praise! thou vagabond!
Thou prostitute! to thy first love return,
Thy first, thy greatest, once unrivall'd theme.
 There flow redundant—like Meander flow
Back to thy fountain, to that parent power
Who gives the tongue to sound, the thought to soar,
The soul to be: men homage pay to men,
Thoughtless beneath whose dreadful eye they bow,
In mutual awe profound of clay to clay,
Of guilt to guilt, and turn their backs on THEE
GREAT SIRE! whom thrones celestial ceaseless sing;
To prostrate angels an amazing scene!
O the presumption of man's awe for man!
Man's author, end, restorer, law, and judge!
Thine all! day thine, and thine this gloom of night
With all her wealth, with all her radiant worlds!

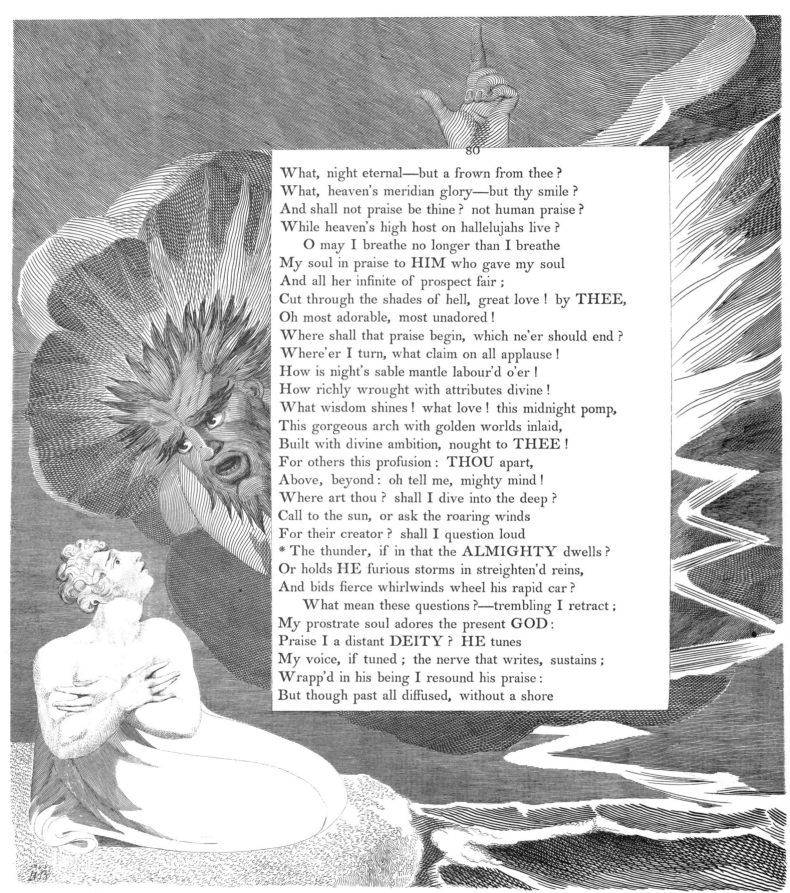

What, night eternal—but a frown from thee?
What, heaven's meridian glory—but thy smile?
And shall not praise be thine? not human praise?
While heaven's high host on hallelujahs live?
 O may I breathe no longer than I breathe
My soul in praise to HIM who gave my soul
And all her infinite of prospect fair;
Cut through the shades of hell, great love! by THEE,
Oh most adorable, most unadored!
Where shall that praise begin, which ne'er should end?
Where'er I turn, what claim on all applause!
How is night's sable mantle labour'd o'er!
How richly wrought with attributes divine!
What wisdom shines! what love! this midnight pomp,
This gorgeous arch with golden worlds inlaid,
Built with divine ambition, nought to THEE!
For others this profusion: THOU apart,
Above, beyond: oh tell me, mighty mind!
Where art thou? shall I dive into the deep?
Call to the sun, or ask the roaring winds
For their creator? shall I question loud
* The thunder, if in that the ALMIGHTY dwells?
Or holds HE furious storms in streighten'd reins,
And bids fierce whirlwinds wheel his rapid car?
 What mean these questions?—trembling I retract;
My prostrate soul adores the present GOD:
Praise I a distant DEITY? HE tunes
My voice, if tuned; the nerve that writes, sustains;
Wrapp'd in his being I resound his praise:
But though past all diffused, without a shore

Pub.ᵈ June 1ˢᵗ 1797, by R.Edwards N° 142 New Bond Street.

His essence; local is his throne, as meet,
To gather the dispersed, as standards call
The listed from afar; to fix a point—
A central point, collective of his sons;
Since finite every nature but his own.
The nameless HE, whose nod is nature's birth;
And nature's shield the shadow of his hand;
Her dissolution his suspended smile;
The great FIRST LAST! pavilion'd high HE sits
In darkness, from excessive splendor; borne
By gods unseen, unless through lustre lost:
His glory, to created glory bright,
As that, to central horrors; HE looks down
On all that soars, and spans immensity.

 Though night unnumber'd worlds unfold to view;
Boundless creation! what art thou? a beam,
A mere effluvium of his majesty:
And shall an atom of this atom world
Mutter in dust and sin the theme of heaven?
Down to the centre should I send my thought
Through beds of glittering ore, and glowing gems;
Their beggar'd blaze wants lustre for my lay,
Goes out in darkness: if on towering wing,
I send it through the boundless vault of stars;
The stars, though rich, what dross their gold to THEE!
Great—good—wise—wonderful—eternal KING!
If to those conscious stars thy throne around,
Praise ever-pouring, and imbibing bliss;
And ask their strain; they want it, more they want,
Poor their abundance, humble their sublime,

Languid their energy, their ardour cold,
Indebted still, their highest rapture burns ;
Short of its mark, defective, though divine.
 Still more—this theme is man's, and man's alone ;
Their vast appointments reach it not : they see
On earth a bounty not indulged on high ;
And downward look for heaven's superior praise :
First-born of ether ! high in fields of light !
View man, to see the glory of your **GOD** !
Could angels envy, they had envied here ;
And some did envy ; and the rest, though gods,
Yet still gods unredeem'd, there triumphs man
Tempted to weigh the dust against the skies,
They less would feel, though more adorn my theme.
They sung creation, for in that they shared,
How rose in melody the child of love !
Creation's great superior, man ! is thine ;
Thine is redemption ; they just gave the key,
'Tis thine to raise and eternize the song ;
Though human, yet divine ; for should not this
Raise man o'er man, and kindle seraphs here ?
Redemption ! 'twas creation more sublime ;
Redemption ! 'twas the labour of the skies—
Far more than labour—it was death in heaven.
A truth so strange, 'twere bold to think it true ;
If not far bolder still to disbelieve.
 Here pause and ponder : was there death in heaven ?
What then on earth—on earth which struck the blow ?
Who struck it ? who ?—O how is man enlarged
Seen through this medium ! how the pigmy towers !

How counterpoised his origin from dust !
How counterpoised to dust his sad return !
How voided his vast distance from the skies !
How near he presses on the seraph's wing !
Which is the seraph ? which the born of clay ?
How this demonstrates, through the thickest cloud
Of guilt and clay condensed, the son of heaven !
The double son, the made and the re-made !
And shall heaven's double property be lost ?
Man's double madness only can destroy.
To man the bleeding cross has promised all ;
The bleeding cross has sworn eternal grace ;
Who gave his life, what grace shall HE deny ?
O ye, who from this ROCK OF AGES leap
Disdainful, plunging headlong in the deep !
What cordial joy, what consolation strong,
Whatever winds arise or billows roll,
Our interest in the master of the storm !
Cling there, and in wreck'd nature's ruins smile,
While vile apostates tremble in a calm.
 Man ! know thyself : all wisdom centres there ;
To none man seems ignoble but to man ;
Angels that grandeur men o'erlook admire :
How long shall human nature be their book,
Degenerate mortal ! and unread by thee ?
The beam dim reason sheds shews wonders there ;
What high contents ! illustrious faculties !
But the grand comment, which displays at full
Our human height, scarce sever'd from divine,
By heaven composed, was publish'd on the cross :

Who looks on that, and sees not in himself
An aweful stranger, a terrestrial God,
A glorious partner with the DEITY
In that high attribute, immortal life?
If a GOD bleeds, he bleeds not for a worm:
I gaze, and as I gaze, my mounting soul
Catches strange fire, eternity! at thee;
And drops the world—or rather, more enjoys:
How changed the face of nature! how improved!
What seem'd a chaos, shines a glorious world;
Or what a world, an Eden; heighten'd all!
It is another scene! another self!
And still another, as time rolls along;
And that a self far more illustrious still!
Beyond long ages, yet roll'd up in shades
Unpierced by bold conjecture's keenest ray,
What evolutions of surprising fate!
How nature opens, and receives my soul
In boundless walks of raptured thought where gods
Encounter and embrace me! what new births
Of strange adventure, foreign to the sun,
Where what now charms, perhaps whate'er exists,
Old time and fair creation are forgot!

 Is this extravagant? of man we form
Extravagant conception, to be just:
Conception unconfined wants wings to reach him:
Beyond its reach the godhead only more.
HE, the GREAT FATHER kindled at one flame
The world of rationals; one spirit pour'd
From spirit's aweful fountain; pour'd himself

Through all their souls, but not in equal stream;
Profuse or frugal of the inspiring GOD,
As his wise plan demanded; and when past
Their various trials, in their various spheres
If they continue rational, as made,
Resorbs them all into himself again;
His throne their centre, and his smile their crown.

 Why doubt we then the glorious truth to sing,
Though yet unsung, as deem'd perhaps too bold?
Angels are men of a superior kind;
Angels are men in lighter habit clad,
High o'er celestial mountains wing'd in flight;
And men are angels loaded for an hour,
Who wade this miry vale, and climb with pain
And slippery step the bottom of the steep.
Angels their failings, mortals have their praise
While here, of corps ethereal, such enroll'd,
And summon'd to the glorious standard soon,
Which flames eternal crimson through the skies.
Nor are our brothers thoughtless of their kin
Yet absent—but not absent from their love:
Michael has fought our battles, Raphael sung
Our triumphs, Gabriel on our errands flown,
Sent by the SOVEREIGN: and are these, O man!
Thy friends, thy warm allies? and thou, shame burn
The cheek to cinder! rival to the brute?

 Religion's all. Descending from the skies
To wretched man, the goddess in her left
Holds out this world, and in her right the next;
Religion, the sole voucher man, is man,

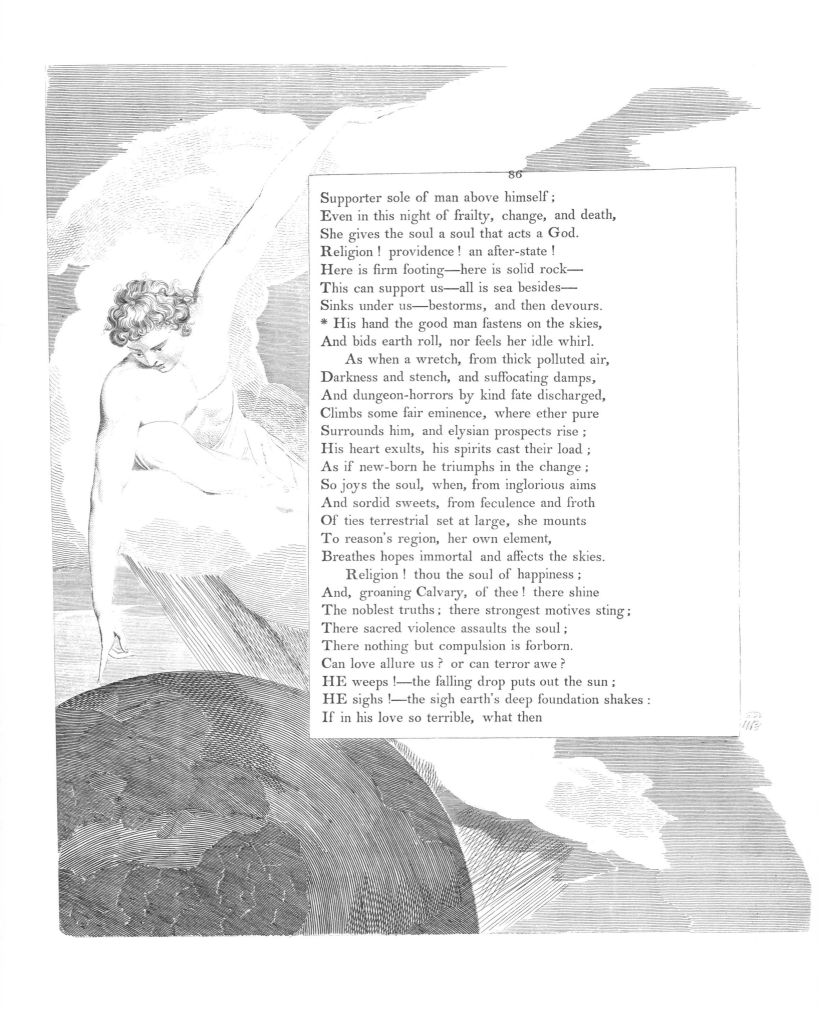

Supporter sole of man above himself ;
Even in this night of frailty, change, and death,
She gives the soul a soul that acts a God.
Religion ! providence ! an after-state !
Here is firm footing—here is solid rock—
This can support us—all is sea besides—
Sinks under us—bestorms, and then devours.
* His hand the good man fastens on the skies,
And bids earth roll, nor feels her idle whirl.

 As when a wretch, from thick polluted air,
Darkness and stench, and suffocating damps,
And dungeon-horrors by kind fate discharged,
Climbs some fair eminence, where ether pure
Surrounds him, and elysian prospects rise ;
His heart exults, his spirits cast their load ;
As if new-born he triumphs in the change ;
So joys the soul, when, from inglorious aims
And sordid sweets, from feculence and froth
Of ties terrestrial set at large, she mounts
To reason's region, her own element,
Breathes hopes immortal and affects the skies.

 Religion ! thou the soul of happiness ;
And, groaning Calvary, of thee ! there shine
The noblest truths ; there strongest motives sting ;
There sacred violence assaults the soul ;
There nothing but compulsion is forborn.
Can love allure us ? or can terror awe ?
HE weeps !—the falling drop puts out the sun ;
HE sighs !—the sigh earth's deep foundation shakes :
If in his love so terrible, what then

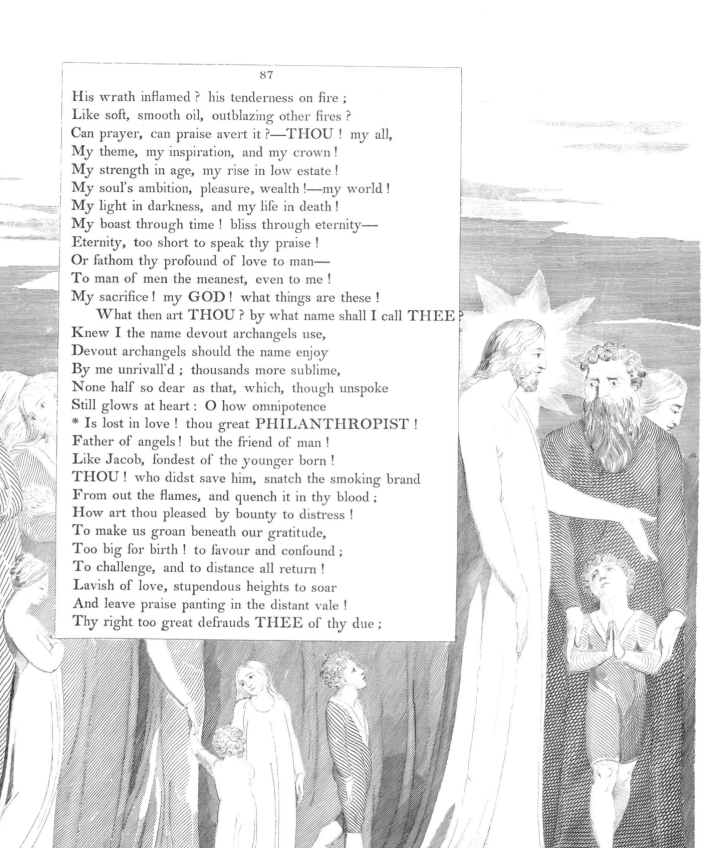

His wrath inflamed ? his tenderness on fire ;
Like soft, smooth oil, outblazing other fires ?
Can prayer, can praise avert it ?—THOU ! my all,
My theme, my inspiration, and my crown !
My strength in age, my rise in low estate !
My soul's ambition, pleasure, wealth !—my world !
My light in darkness, and my life in death !
My boast through time ! bliss through eternity—
Eternity, too short to speak thy praise !
Or fathom thy profound of love to man—
To man of men the meanest, even to me !
My sacrifice ! my GOD ! what things are these !
 What then art THOU ? by what name shall I call THEE ?
Knew I the name devout archangels use,
Devout archangels should the name enjoy
By me unrivall'd ; thousands more sublime,
None half so dear as that, which, though unspoke
Still glows at heart : O how omnipotence
* Is lost in love ! thou great PHILANTHROPIST !
Father of angels ! but the friend of man !
Like Jacob, fondest of the younger born !
THOU ! who didst save him, snatch the smoking brand
From out the flames, and quench it in thy blood ;
How art thou pleased by bounty to distress !
To make us groan beneath our gratitude,
Too big for birth ! to favour and confound ;
To challenge, and to distance all return !
Lavish of love, stupendous heights to soar
And leave praise panting in the distant vale !
Thy right too great defrauds THEE of thy due ;

And sacrilegious our sublimest song :
But since the naked will obtains thy smile,
Beneath this monument of praise unpaid,
And future life symphonious to my strain,
That noblest hymn to heaven ! for ever lie
Intomb'd my fear of death ! and every fear,
The dread of every evil, but thy frown.

 Whom see I yonder, so demurely smile ?
Laughter a labour, and might break their rest.
Ye quietists, in homage to the skies !
Serene ! of soft address ! who mildly make
An unobtrusive tender of your hearts,
Abhorring violence ! who halt indeed,
* But for the blessing wrestle not with heaven !
Think you my song too turbulent ? too warm ?
Are passions then the pagans of the soul ?
Reason alone baptized—alone ordain'd
To touch things sacred ?—oh for warmer still !
Guilt chills my zeal, and age benumbs my powers ;
Oh for an humbler heart, and prouder song !
THOU ! my much-injured theme ! with that soft eye
Which melted o'er doom'd Salem, deign to look
Compassion to the coldness of my breast ;
And pardon to the winter in my strain !
Oh ye cold-hearted, frozen formalists !
On such a theme 'tis impious to be calm ;
Passion is reason, transport temper, here.
Shall heaven, which gave us ardour, and has shewn
Her own for man so strongly, not disdain
What smooth emollients in theology,

Pub.d June 1.st 1797 by R.Edwards N.º142 New Bond Street

Recumbent virtue's downy doctors preach,
That prose of piety, a lukewarm praise ?
Rise odours sweet from incense uninflamed ?
Devotion, when lukewarm, is undevout ;
But when it glows, its heat is struck to heaven ;
To human hearts her golden harps are strung ;
High heaven's orchestra chaunts amen to man.
 Hear I, or dream I hear their distant strain,
Sweet to the soul and tasting strong of heaven,
Soft-wafted on celestial pity's plume
Through the vast spaces of the universe,
To cheer me in this melancholy gloom ?
Oh when will death, now stingless, like a friend
Admit me of their choir ? oh when will death
This mouldering old partition-wall throw down—
Give beings, one in nature, one abode ?
Oh death divine ! that givest us to the skies !
Great future ! glorious patron of the past
And present ! when shall I thy shrine adore ?
From nature's continent immensely wide,
Immensely blest ; this little isle of life,
This dark incarcerating colony
Divides us : happy day ! that breaks our chain ;
That manumits, that calls from exile home ;
That leads to nature's great metropolis,
And re-admits us, through the guardian hand
Of elder brothers to our father's throne ;
Who hears our advocate, and, through his wounds
Beholding man, allows that tender name !
'Tis this makes christian triumph a command :

'Tis this makes joy a duty to the wise;
'Tis impious in a good man to be sad.

 Seest thou, LORENZO! where hangs all our hope?
Touch'd by the cross we live;—or more than die:
That touch, which touch'd not angels; more divine
Than that which touch'd confusion into form
And darkness into glory; partial touch!
Ineffably pre-eminent regard
Sacred to man! and sovereign, through the whole
Long golden chain of miracles which hangs
From heaven through all duration, and supports
In one illustrious and amazing plan!
Thy welfare, nature! and thy GOD's renown!
* That touch, with charm celestial heals the soul
Diseased, drives pain from guilt, lights life in death,
Turns earth to heaven, to heavenly thrones transforms
The ghastly ruins of the mouldering tomb!

 Dost ask me when? when HE who died returns:—
Returns, how changed! where then the man of woe?
In glory's terrors all the godhead burns;
And all his courts, exhausted by the tide
Of deities triumphant in his train,
Leave a stupendous solitude in heaven;
Replenish'd soon, replenish'd with increase
Of pomp and multitude, a radiant band
Of angels new, of angels from the tomb.

 Is this by fancy thrown remote? and rise
Dark doubts between the promise and event?
I send thee not to volumes for thy cure,
Read nature; nature is a friend to truth;

Nature is christian; preaches to mankind,
And bids dead matter aid us in our creed.
Hast thou ne'er seen the comet's flaming flight?
The illustrious stranger, passing, terror sheds
On gazing nations from his fiery train
Of length enormous, takes his ample round
Through depths of ether; coasts unnumber'd worlds
Of more than solar glory; doubles wide
Heaven's mighty cape, and then revisits earth
From the long travel of a thousand years.
Thus at the destined period shall return
HE, once on earth, who bids the comet blaze;
And, with HIM, all our triumph o'er the tomb.
 Nature is dumb on this important point;
Or hope precarious in low whisper breathes;
Faith speaks aloud, distinct; even adders hear,
But turn, and dart into the dark again.
Faith builds a bridge across the gulph of death
To break the shock blind nature cannot shun,
And lands thought smoothly on the farther shore.
Death's terror is the mountain faith removes;
That mountain-barrier between man and peace:
'Tis faith disarms destruction, and absolves
From every clamorous charge the guiltless tomb.
 Why disbelieve—LORENZO?—" Reason bids,
" All-sacred reason"—hold her sacred still;
Nor shalt thou want a rival in thy flame:
All-sacred reason, source and soul of all
Demanding praise on earth, or earth above!
My heart is thine: deep in its inmost folds,

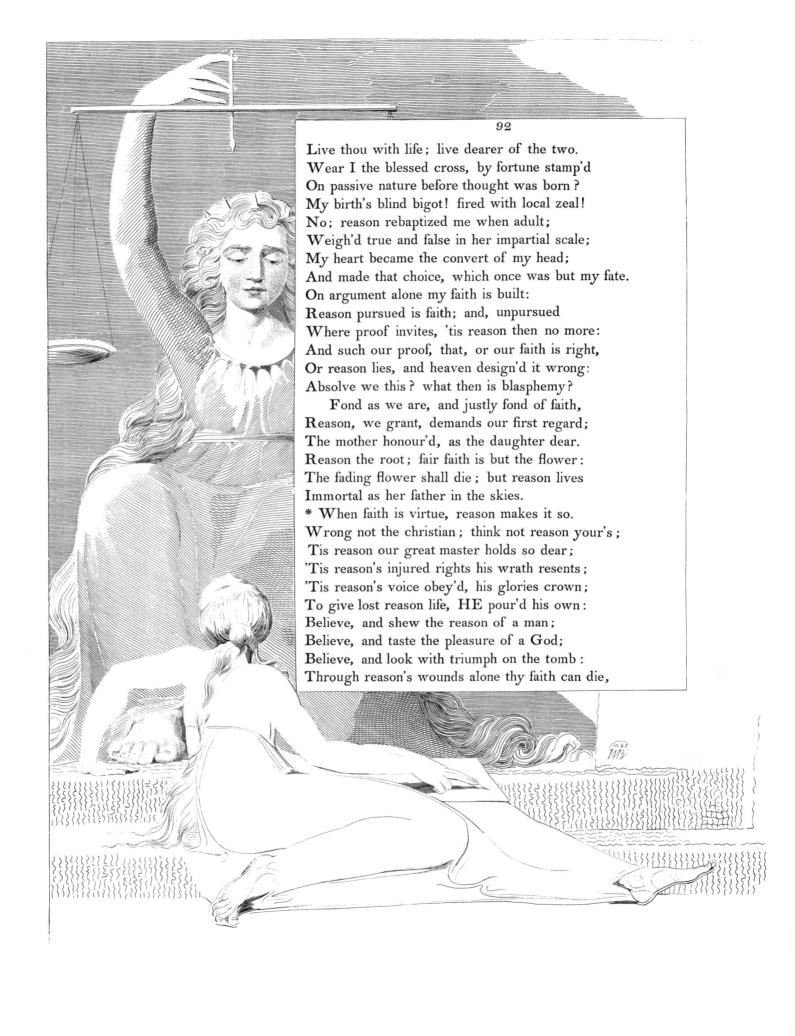

Live thou with life; live dearer of the two.
Wear I the blessed cross, by fortune stamp'd
On passive nature before thought was born?
My birth's blind bigot! fired with local zeal!
No; reason rebaptized me when adult;
Weigh'd true and false in her impartial scale;
My heart became the convert of my head;
And made that choice, which once was but my fate.
On argument alone my faith is built:
Reason pursued is faith; and, unpursued
Where proof invites, 'tis reason then no more:
And such our proof, that, or our faith is right,
Or reason lies, and heaven design'd it wrong:
Absolve we this? what then is blasphemy?

Fond as we are, and justly fond of faith,
Reason, we grant, demands our first regard;
The mother honour'd, as the daughter dear.
Reason the root; fair faith is but the flower:
The fading flower shall die; but reason lives
Immortal as her father in the skies.
* When faith is virtue, reason makes it so.
Wrong not the christian; think not reason your's;
'Tis reason our great master holds so dear;
'Tis reason's injured rights his wrath resents;
'Tis reason's voice obey'd, his glories crown;
To give lost reason life, HE pour'd his own:
Believe, and shew the reason of a man;
Believe, and taste the pleasure of a God;
Believe, and look with triumph on the tomb:
Through reason's wounds alone thy faith can die,

Which, dying, tenfold terror gives to death,
And dips in venom his twice-mortal sting.

 Learn hence what honours, what loud pæans due
To those, who push our antidote aside;
Those boasted friends to reason and to man,
Whose fatal love stabs every joy, and leaves
Death's terror heighten'd gnawing on his heart:
These pompous sons of reason idolized
And vilified at once; of reason dead,
Then deified, as monarchs were of old;
What conduct plants proud laurels on their brow?
While love of truth through all their camp resounds,
They draw pride's curtain o'er the noon-tide ray,
Spike up their inch of reason on the point
Of philosophick wit, call'd argument;
And then, exulting in their taper, cry,
" Behold the sun;" and, Indian-like, adore.

 Talk they of morals? O thou bleeding love!
Thou maker of new morals to mankind!
The grand morality is love of THEE.
As wise as Socrates, if such they were,
Nor will they bate of that sublime renown,
As wise as Socrates might justly stand
The definition of a modern fool.

 A christian is the highest stile of man:
And is there who the blessed cross wipes off,
As a foul blot, from his dishonour'd brow?
* If angels tremble, 'tis at such a sight;
The wretch they quit, desponding of their charge,
More struck with grief or wonder, who can tell?

Pub.^d June 1.st 1797, by R.Edwards, N.º 142 New Bond Street

Ye sold to sense! ye citizens of earth!
For such alone the christian banner fly,
Know ye how wise your choice—how great your gain?
Behold the picture of earth's happiest man:
" He calls his wish, it comes; he sends it back
" And says he call'd another; that arrives,
" Meets the same welcome; yet he still calls on;
" Till one calls him, who varies not his call,
" But holds him fast, in chains of darkness bound,
" Till nature dies, and judgment sets him free;
" A freedom far less welcome than his chain."
 But grant man happy; grant him happy long;
Add to life's highest prize her latest hour;
That hour so late is nimble in approach;
That, like a post, comes on in full career:
How swift the shuttle flies that weaves thy shroud!
Where is the fable of thy former years?
Thrown down the gulph of time, as far from thee
As they had ne'er been thine; the day in hand,
Like a bird struggling to get loose, is going;
Scarce now possess'd, so suddenly 'tis gone;
And each swift moment fled is death advanced
By strides as swift: eternity is all;
And whose eternity? who triumphs there,
Bathing for ever in the font of bliss,
For ever basking in the Deity?
Lorenzo! who?—thy conscience shall reply:
O give it leave to speak; 'twill speak ere long,
Thy leave unask'd: Lorenzo! hear it now,
While useful its advice, its accent mild.

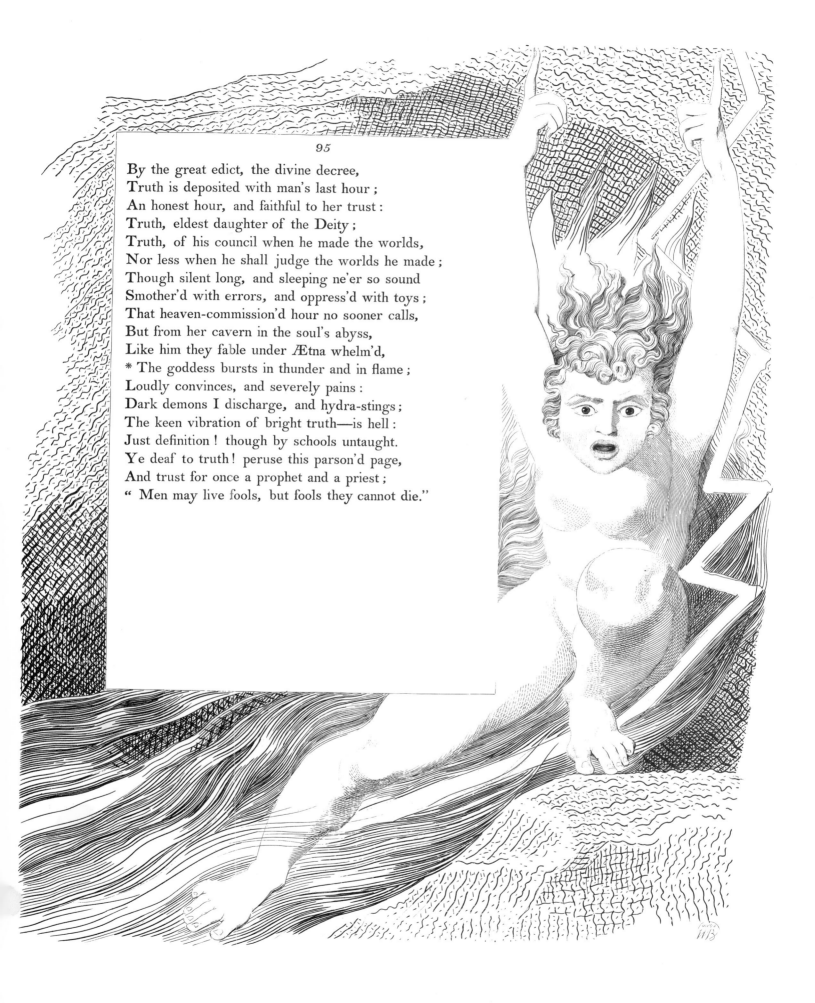

By the great edict, the divine decree,
Truth is deposited with man's last hour;
An honest hour, and faithful to her trust:
Truth, eldest daughter of the Deity;
Truth, of his council when he made the worlds,
Nor less when he shall judge the worlds he made;
Though silent long, and sleeping ne'er so sound
Smother'd with errors, and oppress'd with toys;
That heaven-commission'd hour no sooner calls,
But from her cavern in the soul's abyss,
Like him they fable under Ætna whelm'd,
* The goddess bursts in thunder and in flame;
Loudly convinces, and severely pains:
Dark demons I discharge, and hydra-stings;
The keen vibration of bright truth—is hell:
Just definition! though by schools untaught.
Ye deaf to truth! peruse this parson'd page,
And trust for once a prophet and a priest;
" Men may live fools, but fools they cannot die."